IN AND AROUND
BISHOP'S CLEEVE
THROUGH TIME

David Aldred & Tim Curr

David Aldred.

Tim Curr

AMBERLEY PUBLISHING

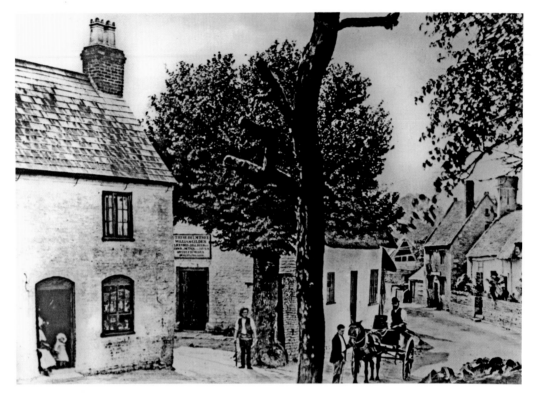

One of the oldest photographs in the book taken *c.* 1895. Compare this with a later view on page 21.

First published 2009

Amberley Publishing Plc
Cirencester Road, Chalford,
Stroud, Gloucestershire, GL6 8PE

www.amberley-books.com

Copyright © David Aldred and Tim Curr, 2009

The right of David Aldred and Tim Curr to be identified as the Authors of this work has been asserted in accordance with the Copyrights, Designs and Patents Act 1988.

ISBN 978 1 84868 809 4

British Library Cataloguing in Publication Data.
A catalogue record for this book is available from the British Library.

Typeset in 9.5pt on 12pt Celeste.
Typesetting by Amberley Publishing.
Printed in the UK.

Introduction

This collection of photographs illustrates the history of Bishop's Cleeve and the surrounding villages of Cleeve Hill, Gotherington, Southam and Woodmancote since the end of the nineteenth century. We hope you, the reader, will enjoy the images as much as we have enjoyed putting them together.

Some of these images, whether taken from commercially produced postcards or from private collections, are already well known but have never been set next to their modern equivalent. However, many have never been seen before, especially those taken in the 1970s and 1980s which so clearly record the great changes which have taken place in the comparatively recent past. So this collection shows how villages which were small, agricultural and declining in the late nineteenth century became the modern thriving settlements of today. This happened at different times in the area. Woodmancote was the first to be affected by the growth of Cleeve Hill village as a health and leisure resort in the early years of the twentieth century after the arrival of the tramway from Cheltenham in 1901. Half a century later the nature of Bishop's Cleeve was changed by the arrival of Smiths' Industries which served as a trigger for more development through to the present century — and is still continuing. Gotherington and Southam developed rather later in the 1960s and 1970s as the motor car brought increased personal mobility and greater choices of where to live and work.

In selecting the photographs we have tried to communicate a flavour of a traditional world and the changes which have led to our world today. In many scenes the changes have been subtle — rendered house walls, television aerials, tarmac roads and pavements. At the other extreme farmland has disappeared under housing developments and we have shown this by choosing a few fascinating 'before and after' scenes — at Pecked Piece Farm in Bishop's Cleeve and at Pottersfield in Woodmancote. Yet what has struck us the most as we have recorded

the modern scene has been the growth of greenery — hedges, bushes and trees which have blocked earlier views and occasionally prevented us re-photographing a scene. Then there has been the claiming of the road by motor vehicles; children no longer play in Church Road in Bishop's Cleeve or pose for the photographer in Cleeve Road in Gotherington, where chickens no longer peck in front of the village hall. At times the car has served our purpose well, for example, replicating an older form of transport as on the front cover; at others it might be seen as an intrusion detracting from the scene being re-photographed. The attendant street furniture of signs, bollards and posts has also sometimes made scenes difficult to re-photograph. But there is no doubt that the motor vehicle's important place in modern life is clearly shown here.

Here, then, is our selection of images illustrating over a century of life and change in a small corner of North Gloucestershire. If it increases your understanding and enjoyment of the area, our hard work will have been worthwhile.

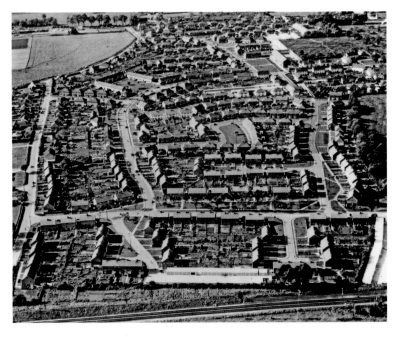

This aerial view looking west shows Smiths' estate shortly after completion in the mid 1950s.

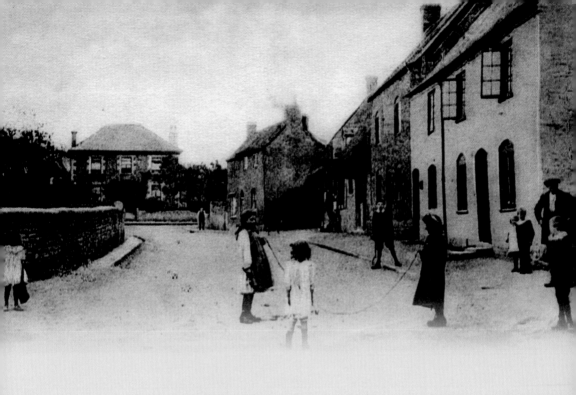

chapter 1

Bishop's Cleeve

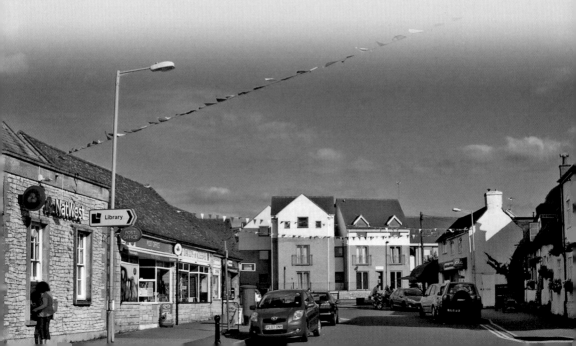

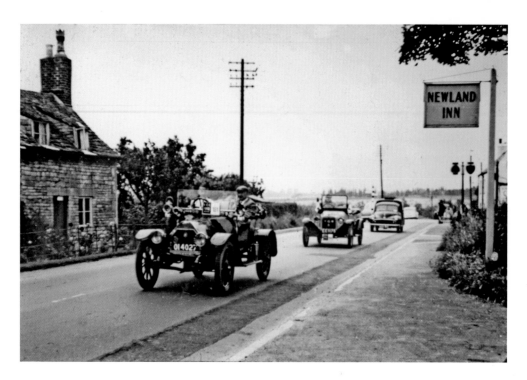

The Newlands

Today the road from Cheltenham is the main route into Bishop's Cleeve. Only the Newlands Park sign stands as a reminder of the small hamlet which stood here until the early 1950s shortly after the upper photograph was taken. In it can be seen Bookham Cottage, the petrol station and the inn sign. Out of sight between the petrol station and inn stood a large villa with a small café.

Grange Farm

The only remnants of Grange Farm are the two Cotswold stone cottages fronting onto Cheltenham Road. The farm was attached to The Grange which was built by Cheltenham solicitor, Frederick J. Griffiths in 1865. By 1900 his farm extended to ninety acres. His farm bailiff lived here and was employed so Frederick could almost live the life of a country gentleman and become heavily involved in community affairs. The earlier photograph was taken in 1979.

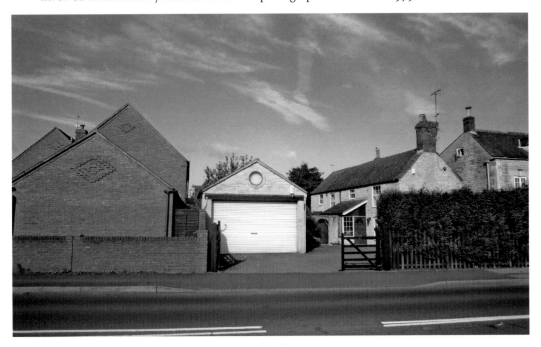

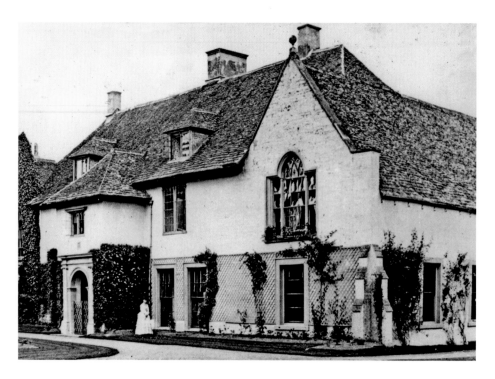

Cleeve Hall

The exterior is little changed since the time of Rector Benjamin Hemming (1883-1895) whose daughter poses by the porch. Built *c.* 1250 for the Bishop of Worcester, it became the home of the rector of Bishop's Cleeve in 1624. Above the porch the date 1667 marks the year it was added and the interior 'modernised'. In 1975 it became the headquarters of the Oldacre company and, more recently, of Bovis homes.

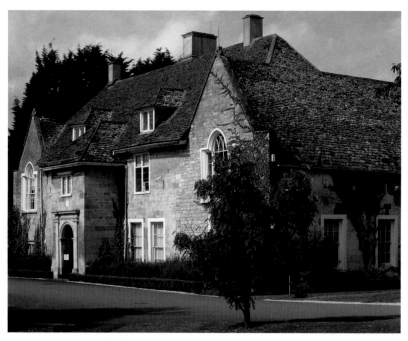

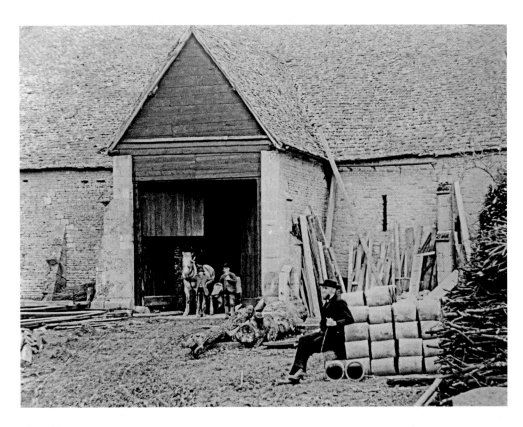

The Tithe Barn

Opposite the former rectory stands the tithe barn, which was originally built for the Bishop of Worcester in 1465. It became a tithe barn when Timothy Gates bought the former bishop's manor house in 1624. Benjamin Hemming sits outside the entrance not long before the barn was reduced to its present size. Converted into a village hall in 1956, the extension being built in the summer and autumn of 2009 will return it almost to its original shape.

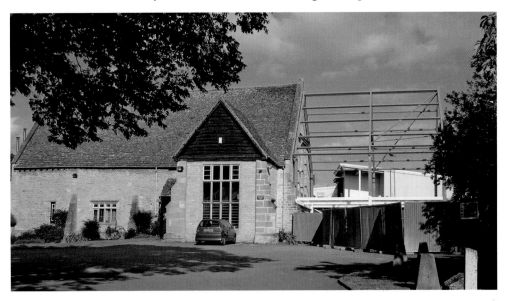

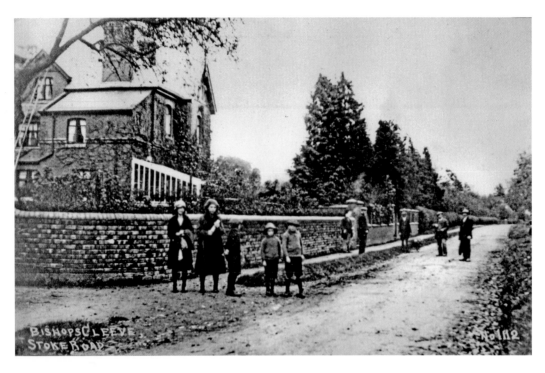

Lake House, Stoke Road

Stoke Road runs opposite the tithe barn, although since the bypass was built it has become a cul-de-sac. Lake House was built as a gentleman's residence at the end of the nineteenth century near a lake which was the result of clay digging for the nearby brickworks. It was demolished in 1988 and today only the name survives.

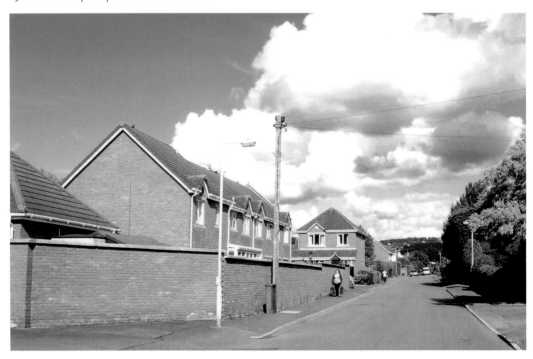

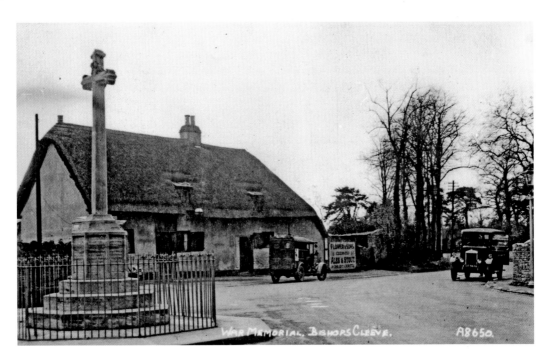

The King's Head and War Memorial

The junction of Church Road and Cheltenham Road was the most popular location for Edwardian and later postcards. Except for the removal of the war memorial, this angle of the junction has changed very little in the past century. The King's Head has been a public house for well over 150 years. According to Ernie Freebery, writing in 1927, about the time of the earlier view, Flower's ale cost 7*d* (3p) a pint.

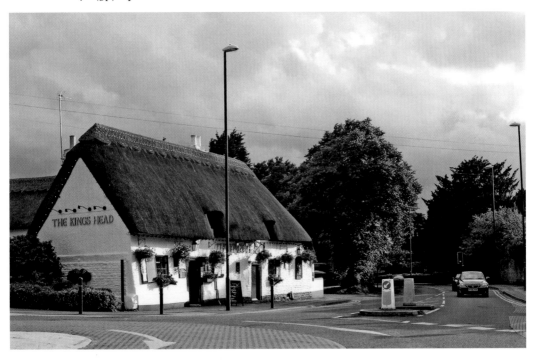

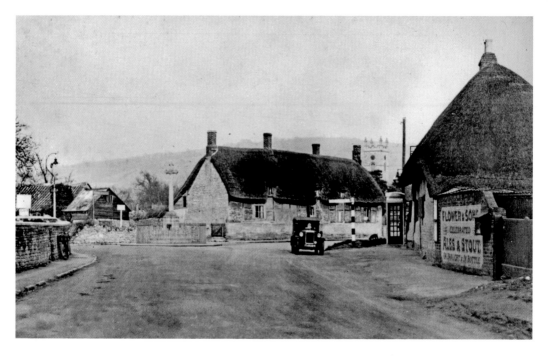

Change Means Progress (I)?

Looking across the junction from the King's Head, the centre of this scene was completely transformed in the early 1960s when the old barn, which had been converted into three cottages, was demolished giving way to a row of shops of urban design. It was in these years that Church Road generally was transformed into the shopping area of the village. The telephone box arrived in 1938, giving a clue to the date of the upper photograph.

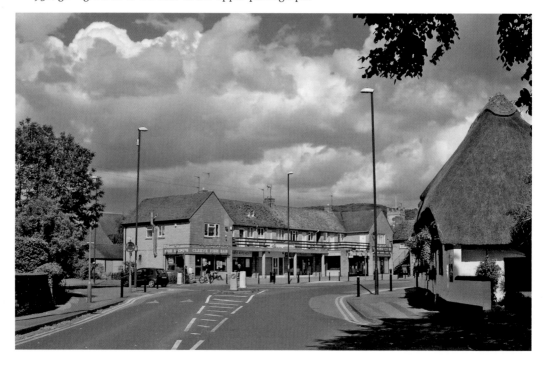

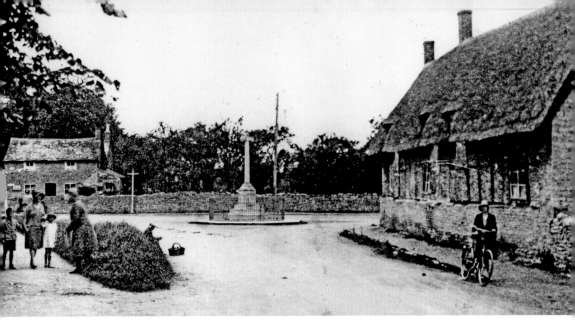

Change Means Progress (II)?
Despite the great changes in the centre of Bishop's Cleeve, there are sometimes surprising survivals from an earlier age. Here a patch of grass provides a point of reference. In the upper image of the 1920s it provides a place of refuge for a weary shopper and gossiping villagers. In the distance the old post office and wall provide the only other identifiable features in the modern scene.

Tesco

The upper image will be very familiar to the majority of people who now come to do their shopping in Bishop's Cleeve. The lower picture was taken in 1993, three years before the closure of Oldacres' Mill that had been on this site for just over a century. Before the arrival of Smiths' Industries, Oldacres had been the village's largest single employer. Note how the telephone box has been moved from its earlier site by the King's Head.

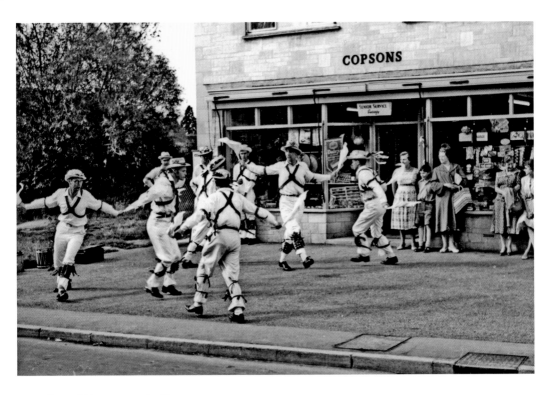

From Newspapers to Pizzas

Morris men perform *c.* 1960 outside the recently built newsagents. Later it expanded into a general store before suffering from supermarket competition. It now forms part of the fast food and café/restaurant 'quarter' of the village. Readers are again invited to consider whether change always means progress.

The Cottage Loaf

The Cottage Loaf tea room stands between the Spinning Wheel haberdashery and the old fire engine house in the upper view from the early 1970s, when four-star petrol cost 34p a gallon. Oldacres' garage can just be made out at the rear. These buildings were demolished in 1976 after the Cottage Loaf had suffered a fire in the previous year. They were replaced by Mill Parade.

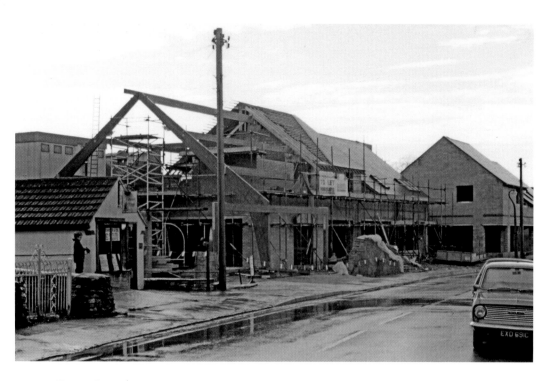

Mill Parade

In the 1970s Peter Lewis, head of the art department of Cleeve School, began to record the changes taking place in the local area. Here the scene he recorded shows Mill Parade under construction with the Spinning Wheel in the left foreground in its last use as Candler's estate agency. The modern view was taken on a very quiet Sunday morning and provides an excellent example of the growth of street furniture, as noted in the introduction.

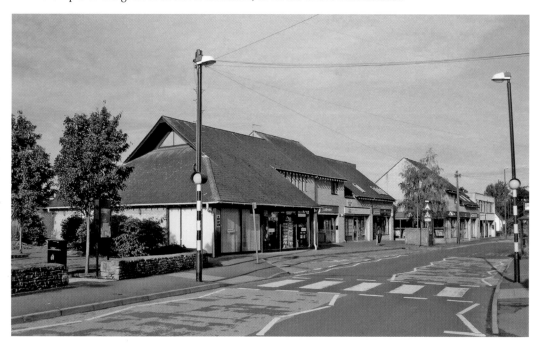

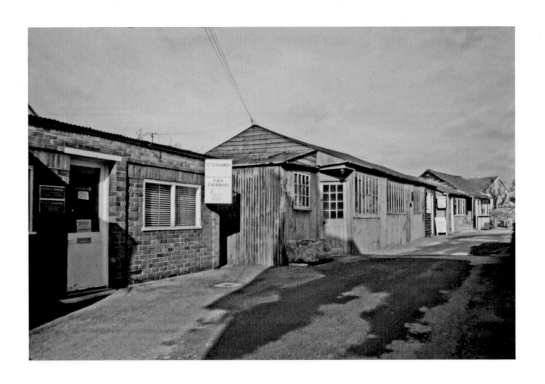

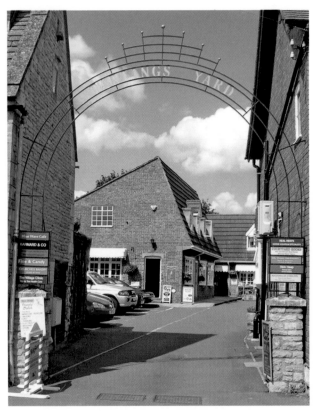

Tarling's Yard

Another local photographer aware of the need to record the old village was the late Bill Potter of Meadoway. Bill is well known for his railway photographs, but here he recorded Tarling's Yard in 1979 just before Peter and Denise Harwood converted the ramshackle workshops into twelve modern commercial units. Peter's original workshop can be seen in the upper photograph. He chose the name Tarling's Yard to keep alive the memory of a long-lived family of village craftsmen.

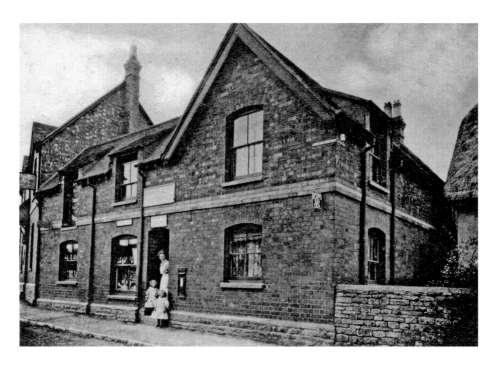

Beckingsale's Shop

Moving up Church Road we come to Beckingsale's shop, which provided almost the only grocer's shop in Bishop's Cleeve during the first half of the twentieth century. The top photograph was taken *c.* 1910 and shows Mrs Beckingsale standing at the door with her two small children. The inset photograph shows Norman and Derrick Blake just before closure of the shop in 1984. After many years of neglect it is now the premises of Alexander Burn, the village's undertaker.

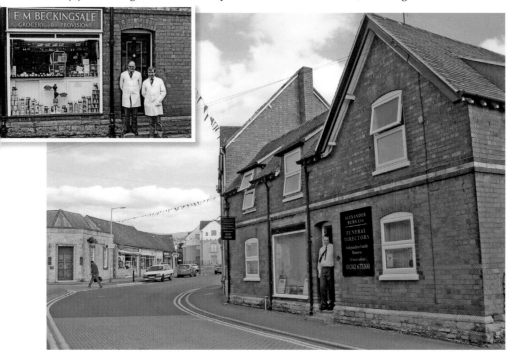

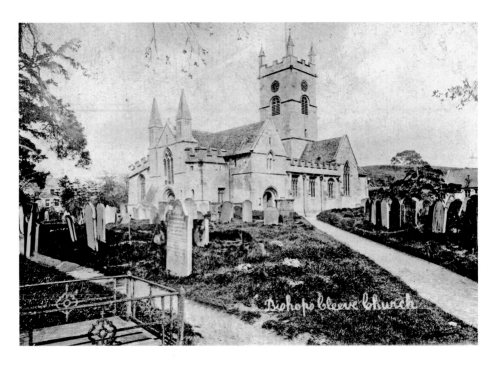

St Michael's Church

There has been a church here since at least the eighth century when it provided a focus for a settlement that became the village of Bishop's Cleeve. The gravestones provide the evidence that the upper view dates from 1884-1890 which possibly makes this the oldest photograph in the book. The growth of modern greenery has prevented an exact replica photograph, although the railings surrounding a grave in the bottom left corner provide a point of reference.

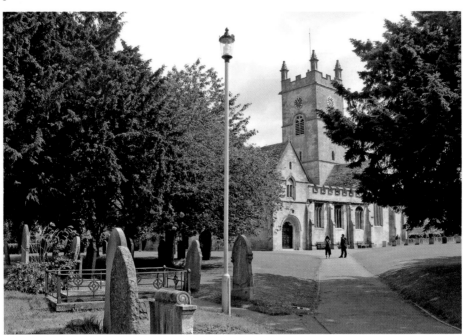

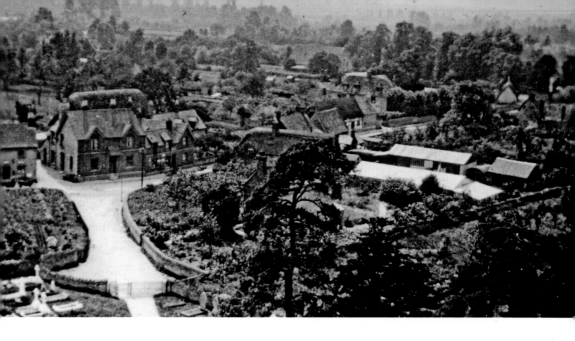

Church Road

The earlier view was taken from the tower of St Michael's church in 1928. In this fascinating comparison a few of the buildings can still be made out, notably the redbrick former Elm Tree Inn and Tarling's Yard. However, the orchards and gardens have mostly disappeared as the centre of the village has lost its rural appearance. The two modern large-scale developments of Tesco and Zurich/Capita can also be seen in the lower picture.

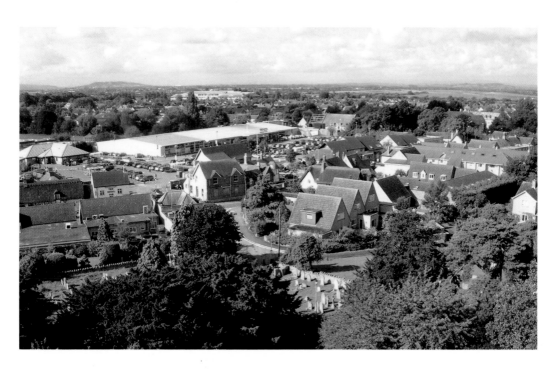

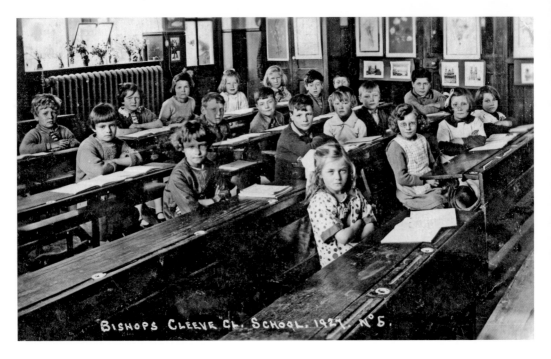

Bishop's Cleeve School

The school opposite St Michael's was built in 1847 by the church authorities for the local children. Until 1956 children could spend their whole school life here, as, no doubt, did the youngsters in this senior class of 1927. Their room was at the back of the building in what was originally the schoolmaster's house and is now the church office.

The Royal Oak

It is difficult to imagine today how dilapidated the back of the Royal Oak appeared in 1972 when the lower photograph was taken. A comparison with the front cover will show that two houses next to the Royal Oak had already been demolished to provide an entrance to the car park by the time of the photograph.

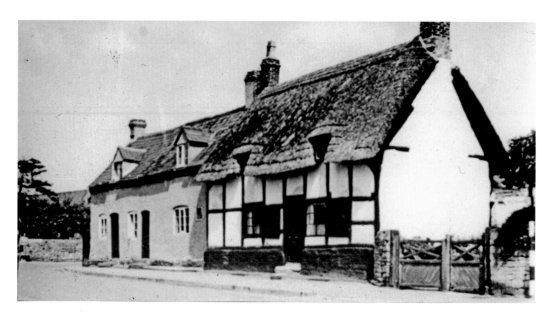

The War Memorial Site

Here begins a double-page sequence of the present site of the war memorial with the Cotswold stone wall in the left background providing the point of reference. The two country cottages shown in the top view were demolished when Church Road was realigned in the late 1950s. The old name for this area of the village was Cheapside — a place of trading. There were shops here in the fifteenth century, but they, like the name itself, are now long forgotten.

The War Memorial Site

The demolition left a house isolated on the site until 1977 when it in turn was demolished. Three years later the war memorial was moved from its original site where it was 'only one drunken lorry driver away from destruction', according to a report in the *Gloucestershire Echo*. Observant readers will notice the shortened shaft, damaged in the removal. Today the post-war prefabricated classrooms of the school have been replaced by Rectory Court sheltered housing.

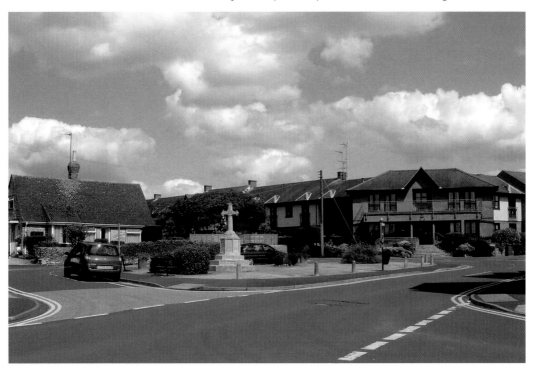

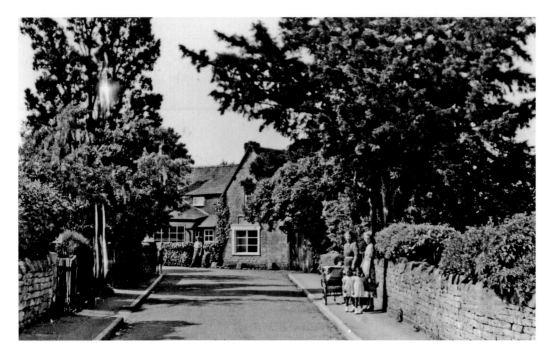

Tobyfield Road

Turning right at the war memorial into Tobyfield Road, these views show how its alignment has changed. In the top view stands Edginton's bakery — one of two village bakeries. It opened in 1830 and closed in 1953 about the time the upper view was recorded. For another fifteen years it served as a general store before demolition led to the road realignment and the building of two new shops. The two boundary walls remain.

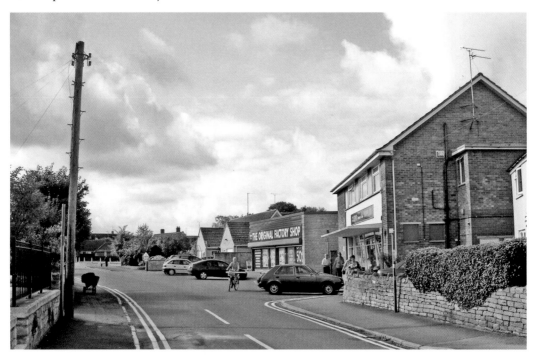

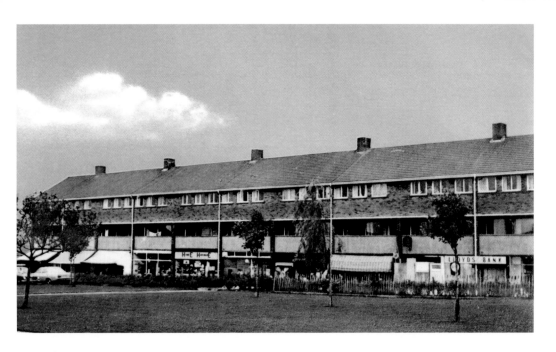

The Green

These shops provided one of the few amenities on Smiths' estate. They were sufficiently noteworthy to be the subject of a postcard from a firm in Leicester *c.* 1960 when they were comparatively new. Today the trees have grown, the car park has doubled in size, several of the small shops have disappeared and the balconies have been enclosed, but the scene is still recognisable.

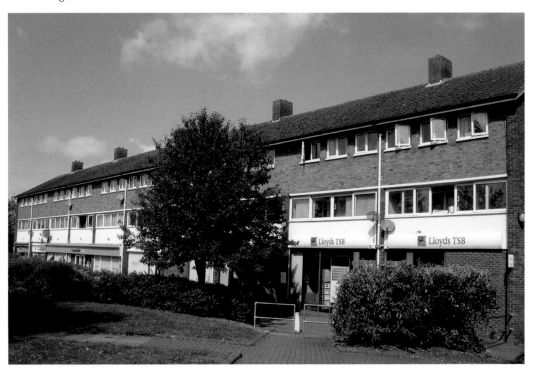

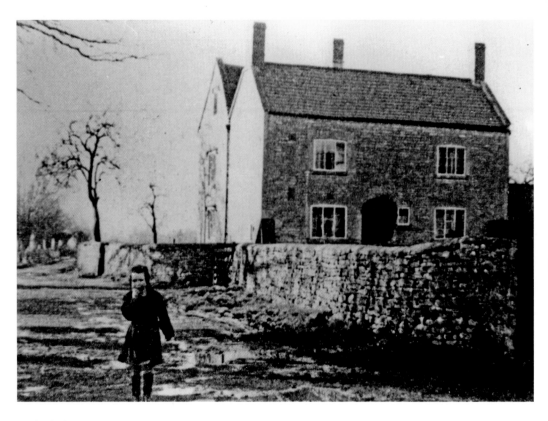

Pecked Piece Farm

Linda Field stands by the farmhouse in a very muddy Pecked Lane in 1954. Bert Long's farm stood on the footpath route from Bishop's Cleeve to Woodmancote. His farmhouse stood more or less in the garden of the second house where Pecked Lane now meets Lynworth Road. The hedge line on the left provides a clue to the general location.

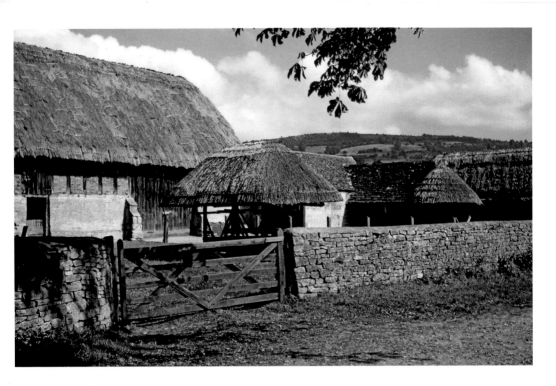

Pecked Piece Farm
A glimpse of Nottingham Hill helps us to locate the site of the farmyard with the blank redbrick wall of the third house marking its eastern boundary. Its rustic nature gives a clear indication of the rural tradition which has been lost in the village during the past half century. Ashfield, Oakfield and Withyfield roads were built on its land in the 1960s.

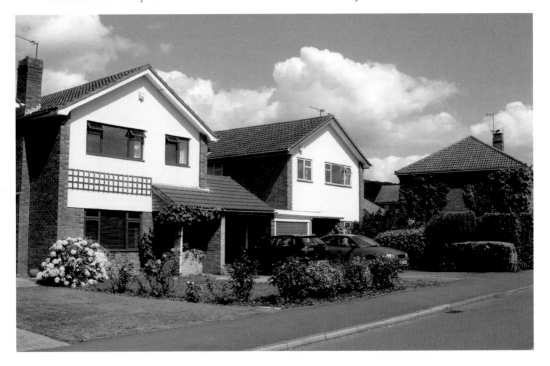

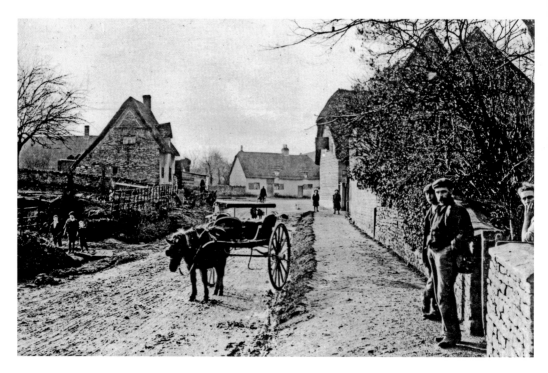

Evesham Road

We now return to the King's Head to travel up Station Road. Here is one of the most iconic images of the old village taken from Gilders' Home Farm in 1905. All the buildings except the King's Head have been demolished and on the left Gilders' Paddock became a retirement home development in 1990. Cars have replaced carts and no one now poses for a photograph but pedestrians remain.

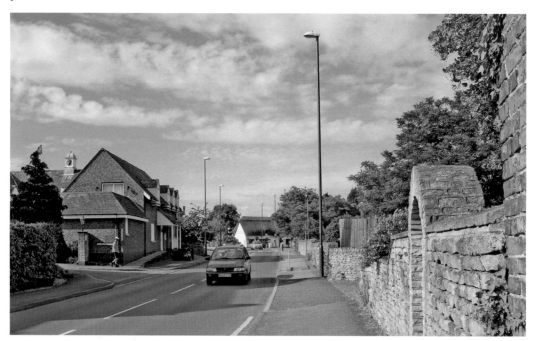

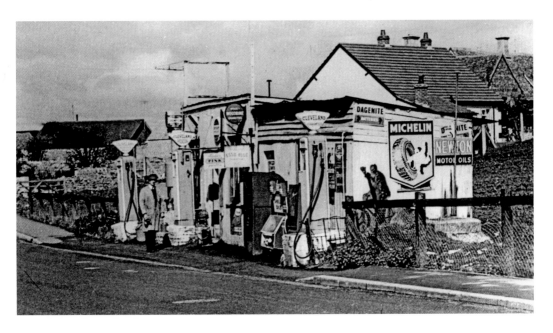

Joe Powers' Garage

Joe Powers' cycle repair shop was already selling 'motor spirit' from cans when Ernie Freebery arrived in Bishop's Cleeve in 1927. Apart from the construction of pumps the garage continued largely unchanged until closure in the 1970s. A Cheltenham-bound bus enlivens the featureless modern view of the Cotswold stone wall built across the site.

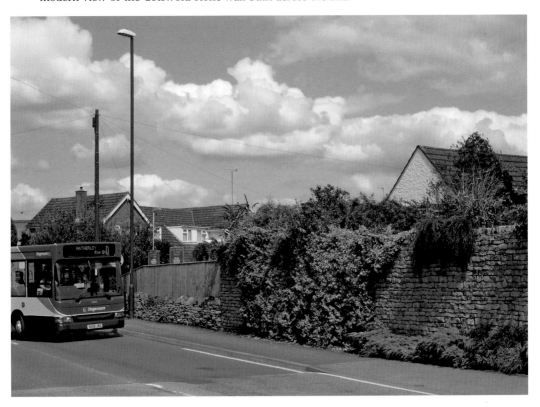

Finlay Way

The most recent expansion of Bishop's Cleeve has been westwards towards the bypass. In the top picture the line of Finlay Way has just been defined by the removal of the topsoil in June 1989. The hedge to the right still survives along the line of the garden wall in the bottom picture. St Michael's tower can be glimpsed through the trees to the right of centre. The road's name commemorates Doug Finlay, for many years clerk to the parish council during the early years of these developments.

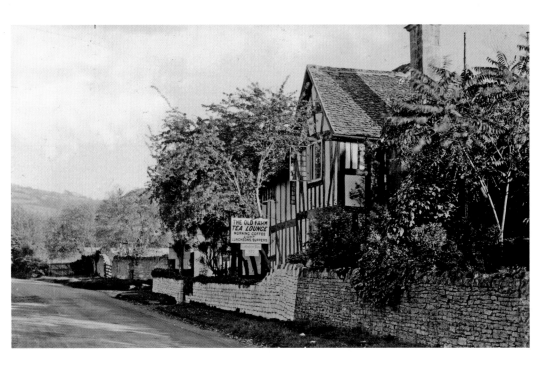

The Old Farm

At the bottom of Station Road, the Old Farm dates from the late fifteenth century. Its prestigious architecture has saved it from the fate of so many other timber-framed houses in the village centre. In more recent years it has been a racing stable and, at the time of the upper image in the late 1920s, a tea garden for visitors enjoying the newly-developing leisure activity of a tour by car into the countryside.

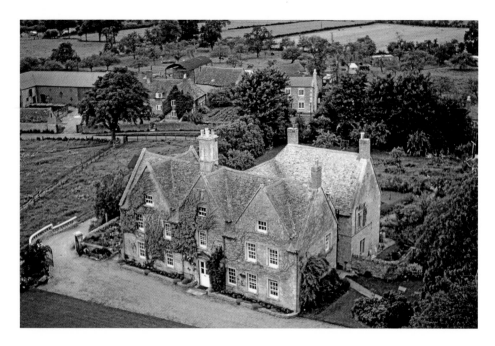

The Priory

The Priory was the site of the original rectory. The architecture of the present house indicates how it was rebuilt after the rector had moved out in 1624. Historically this lower part of Station Road was home to the more affluent members of the village community whose houses largely survive. The upper view was taken in 1960 shortly before Oldacres sold their land at Cleevelands Farm (top left) for the building of the Cleeveview estate.

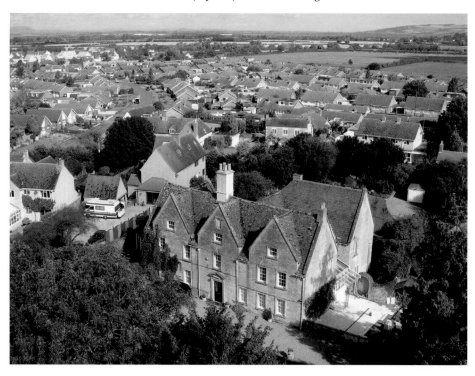

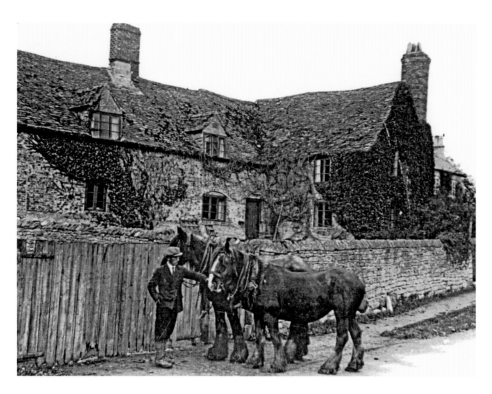

Cleevelands Farm

Cleevelands Farm in Station Road is another lost farm of Bishop's Cleeve. It was the home of the Minett family until 1942 when it came into the hands of Oldacres. In the upper picture, taken in 1921, Jack Minett poses by the gate with his horses. Today all trace of the farm has gone except the farmhouse. It is over 500 years old but its timber-framed origins are masked by the more recent brick walls.

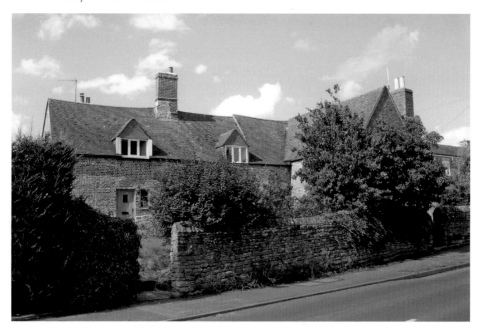

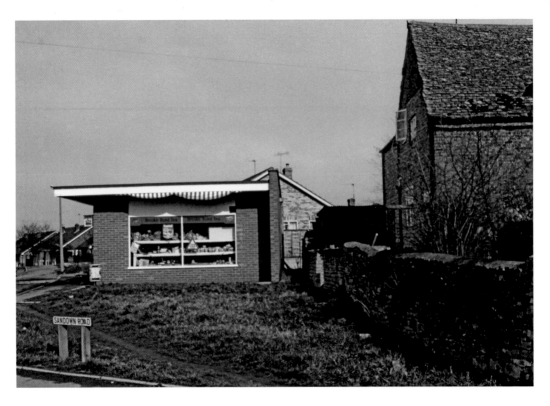

Sandown Stores

This entrance to Cleeveview estate runs at the side of the former farmhouse of Cleevelands Farm. Sandown Stores was built here at the entrance so that the inhabitants did not have to travel into the village centre for their groceries. It closed and was converted into a dwelling when it could no longer compete with the larger shops in the village.

'The Street'

This lower part of Station Road, where the richer villagers lived, was known for centuries as 'The Street'. The Old Manor House can be seen in the distance in both these photographs, on the far side of a row of labourers' cottages built in the early nineteenth century. In the early twentieth century a small boy stands in the road near where cars would park a century later. The small area of grass is another chance survivor through a century and more of change.

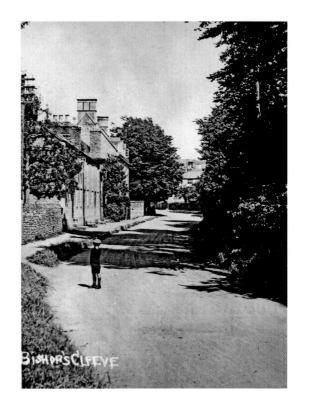

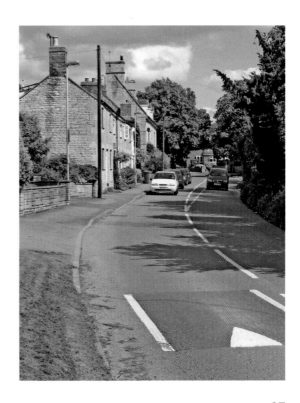

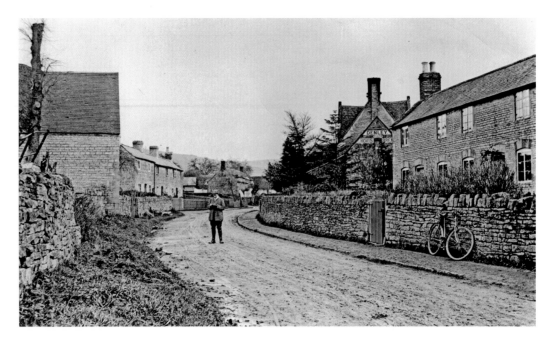

Denley's Bakery

In the photograph of 1910 a lone cyclist has stopped in Station Road. Behind him a sign on Eversfield House proclaims Denley's bakery. Two years later George Denley bought items from a children's playground in Charlton Kings and rebuilt them in his orchard — Eversfield Tea and Pleasure Grounds were born. For nearly thirty years they continued to attract day-trippers from all over Gloucestershire and further afield for whom Bishop's Cleeve meant only one thing: the tea gardens.

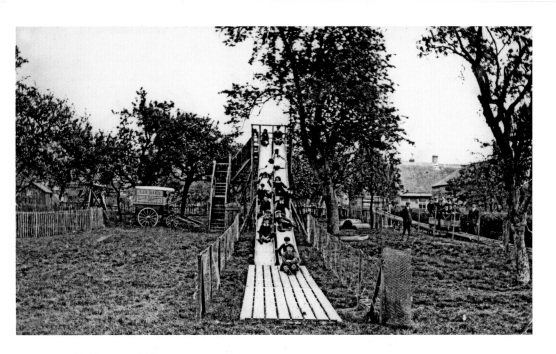

Eversfield Tea and Pleasure Grounds

The gardens were conveniently situated near the railway station and most visitors arrived by train. The rustic nature of the attractions is clearly shown in the upper photograph; splinters were clearly a hazard on this slide! The position of timber-framed St Michael's cottage gives a point of reference in the lower view. The pleasure grounds closed at the outbreak of war in 1939 when the buildings were used for billeting troops.

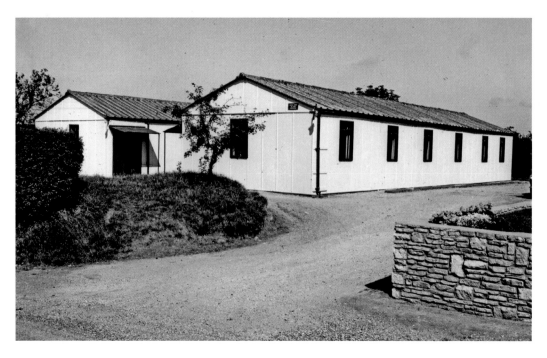

Bishop's Cleeve Old Folks' Association

In 1947 George's son Alick helped set up the Old Folks' Association. Two wartime hostels were refurbished and re-erected on the Priory Lane side of the former pleasure grounds. They were photographed in 1975 after Dulux sponsored a repaint and requested photographic evidence that the paint had actually been used! The modern wider view of Priory Lane contains the same Cotswold stone wall. The association's present building is near St Michael's Hall and carries the name Denley Hall in commemoration.

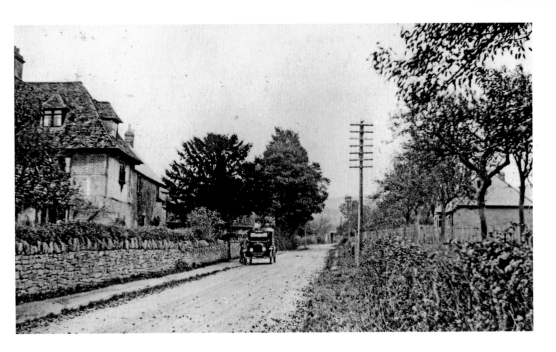

Owl's End House

To the east of Eversfield House, Owl's End House is another former farm, in this case Rigby's farm, seen above in the 1920s. By 1885 Walter John, the founder of Oldacres, was using a steam engine to grind animal feed in a small side building which still survives.

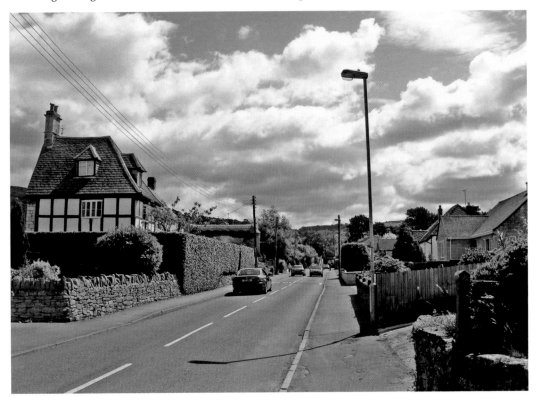

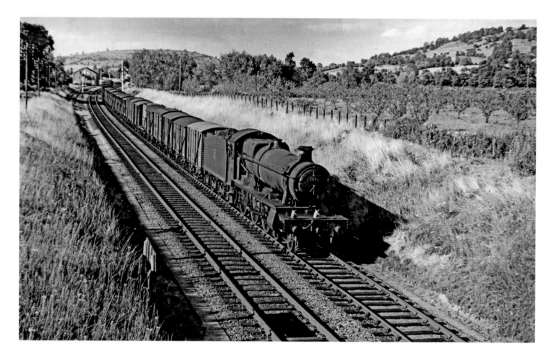

Bishop's Cleeve Station

In the top view of *c.* 1955 a goods train has just passed through Bishop's Cleeve station. The station opened in 1906 on the Great Western Railway's new main line from Birmingham to Bristol. It closed in 1960 and the site has been largely built over. The line itself was closed completely in 1976 and the rails removed. Since 1981 the Gloucestershire and Warwickshire Railway Society has reconstructed the track which has conveniently provided the opportunity for the modern photograph.

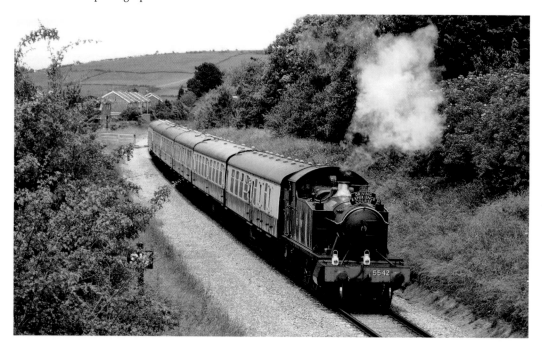

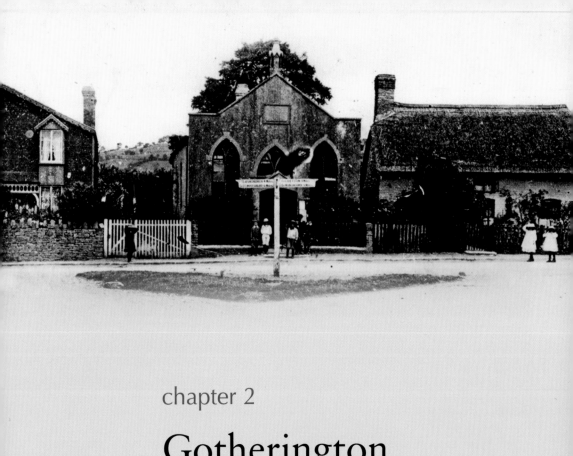

chapter 2

Gotherington

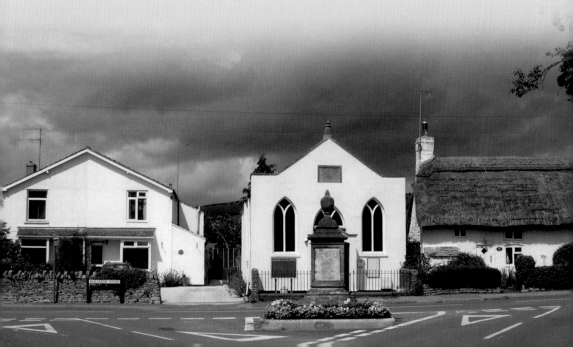

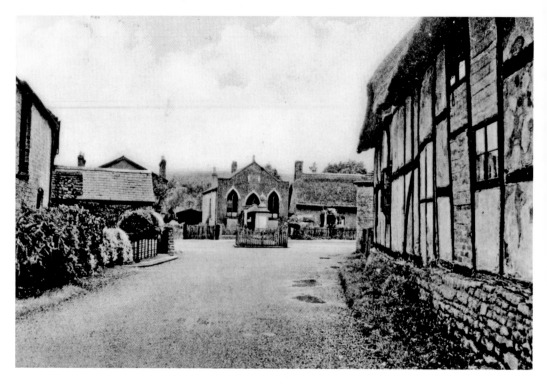

The War Memorial

Compared to the previous page, the war memorial has replaced the finger post in front of the chapel. There has been a chapel here in the centre of Gotherington since 1833, but Woodbine Cottage to the right has been here at least 200 years longer. The Stocks on the extreme right in the upper view was demolished in the late 1920s.

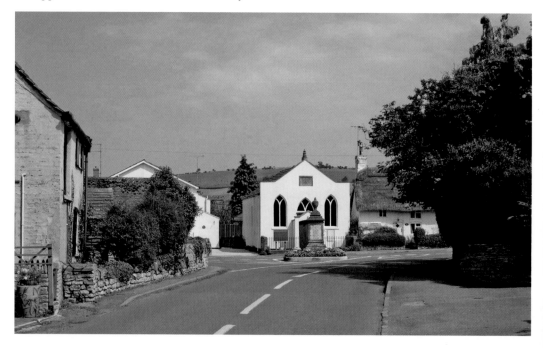

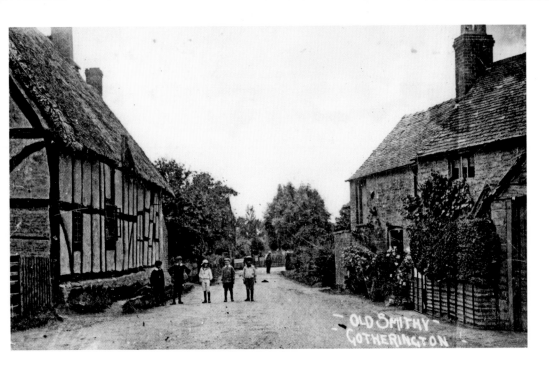

View Down Cleeve Road

The Stocks can be seen here on the left in the view along Cleeve Road taken in the 1920s. The smithy still stands on the right. The inset shows the smithy in use around the turn of the twentieth century when it was in the hands of the Sollis family.

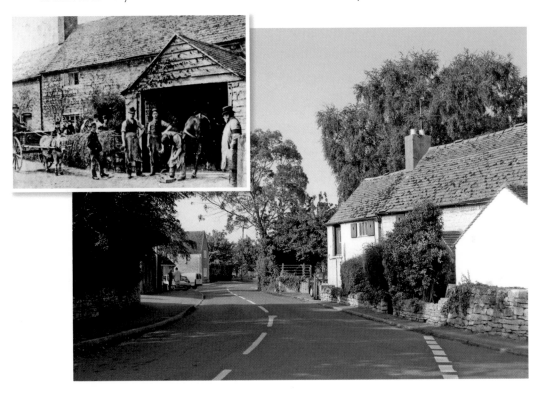

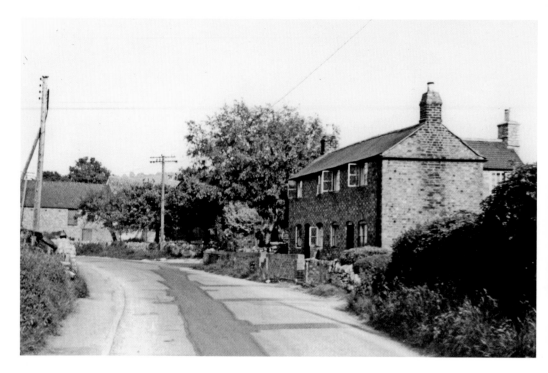

Rhondda Cottage

Rhondda cottage on the right was originally built before 1800 as the poorhouse for the neighbouring parish of Woolstone. The upper picture was taken shortly after the main sewer was laid through the village in 1960. In the lower view the telegraph pole remains and the horse warning sign and bus stop provide good examples of modern street furniture.

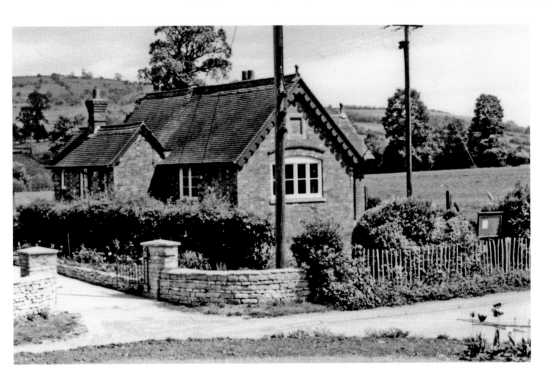

The Village Hall

The present village hall dates back to 1903 as a reading room to encourage men and older teenage boys out of the pub and into 'improving' activities like reading, listening to lectures and playing draughts and dominoes. The original reading room was started by Mrs Malleson of Dixton and was held in two rooms at Ivyville, lower down Malleson Road. Even in 1960 the hall stood next to fields and hens could peck peacefully on the narrow road.

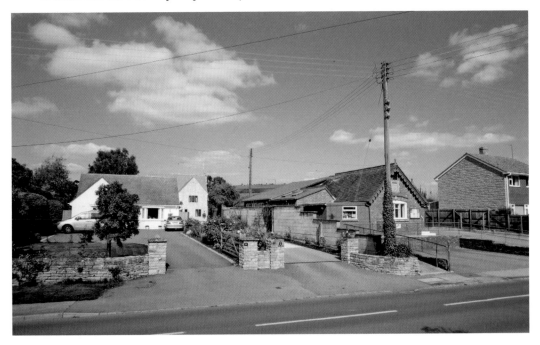

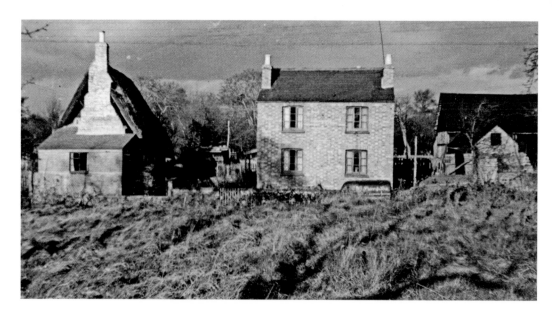

Elm and Church View Cottages

Fifty-five years separate these two photographs. The upper one, taken from Till's field, shows a lean-to kitchen which was demolished when the road was widened. Also in the view is Price's baker's delivery van from the village bakery in Gretton Road, which continued until 1990. Church View cottage lost its view to Bishop's Cleeve when Till's field was built upon and is now Pear Tree cottage.

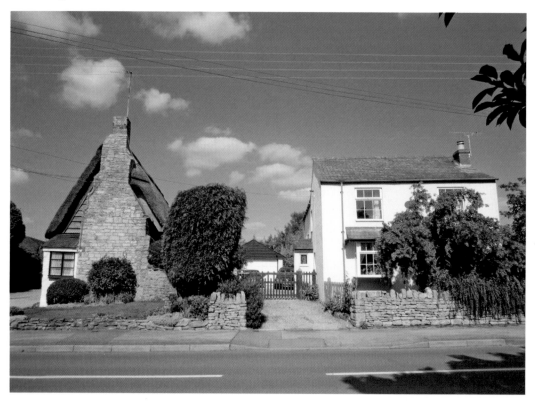

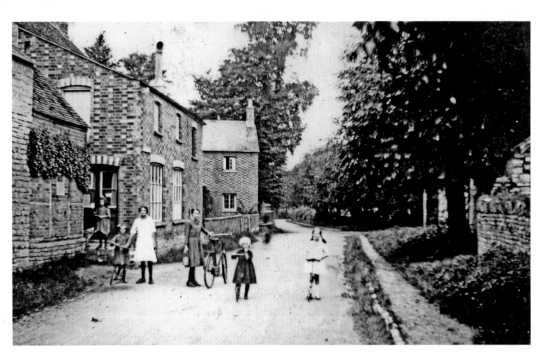

Ivyville

In the top picture people have time to pose in the road in front of Ivyville — an important building in the years under study in this book. Home to the first reading room in 1885 and to Anglican church services in the 1920s, in the years between it also served as the village post office. The inset picture records the demolition, in the early 1990s, of the brick-fronted extension to reveal the original Cotswold stone villa.

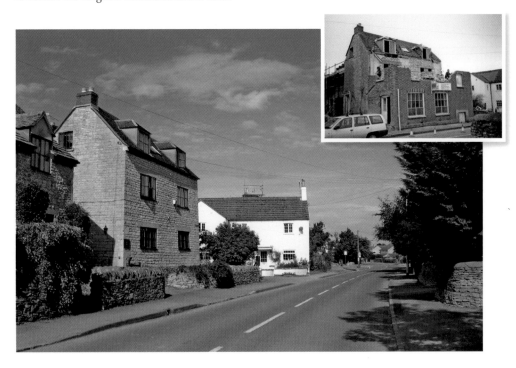

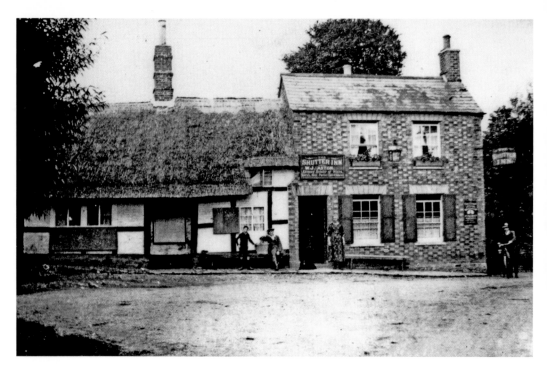

The Shutter Inn

The Shutter Inn, or The Shutters, has been a public house for at least 200 years. It brewed its own beer until 1892 when it was taken over by the Cheltenham Original Brewery. The upper photograph, taken *c.* 1925, shows the building in an intermediate state between the original timber-framed construction and the modern all-brick building.

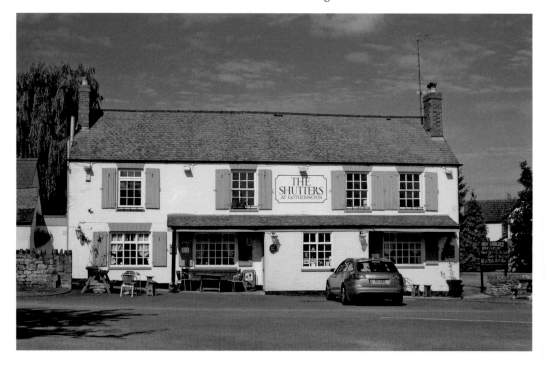

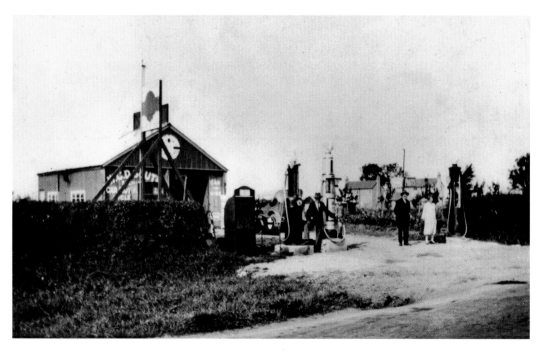

Gotherington Cross Garage

There has been a garage here on the Evesham Road since the date of the upper view of *c.* 1930, in which the South family stand proudly by the petrol pumps. The garage later passed to Dickie Barrow who older residents will remember. The modern garage dates from 1990 but the petrol prices indicate a much more recent photograph!

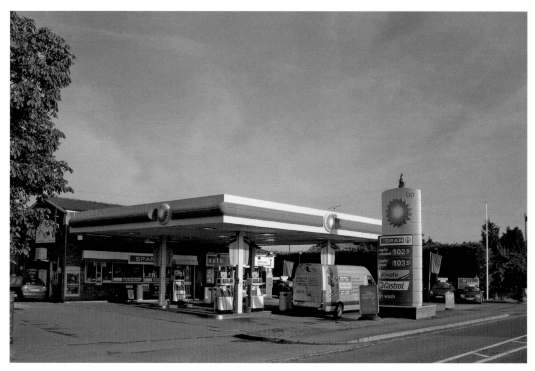

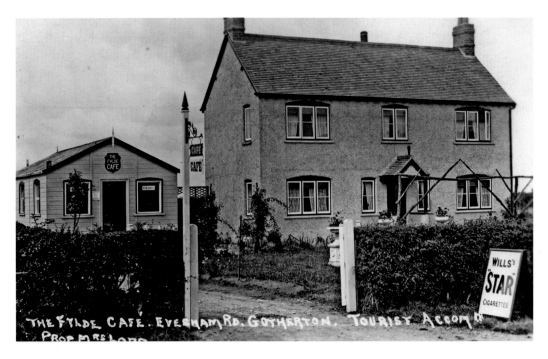

THE FYLDE CAFÉ. EVESHAM RD. GOTHERTON. TOURIST ACCOM^D
PROP MRS LORD

Mrs Lord's Café

The growth of car usage in the interwar period saw the growth not only of garages but also of roadside cafés and tea rooms to cater for the middle class tourists enjoying trips into the countryside. The Newlands and Old Farm in Bishop's Cleeve are two examples already seen on earlier pages, but Mrs Lord also offered tourist accommodation. The buildings are still recognisable today.

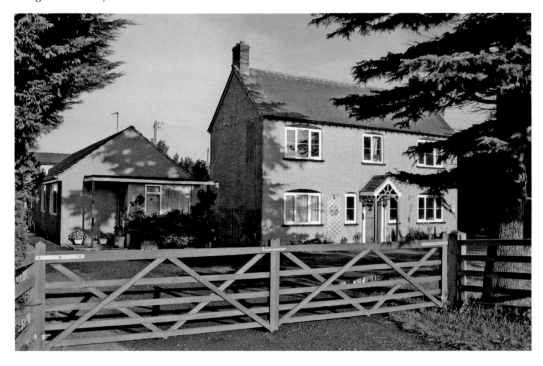

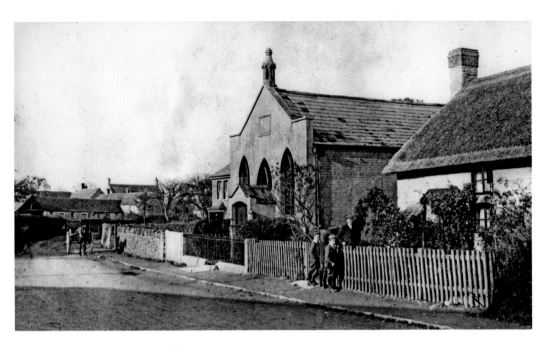

Back to the War Memorial

This view of the chapel and Woodbine Cottage has changed only superficially since 1904 when Bruce Pitman was photographed in his front garden. The car has replaced the pony and trap and the road has been tarmacked, a television aerial has appeared and the finger post has been moved from the site of the war memorial.

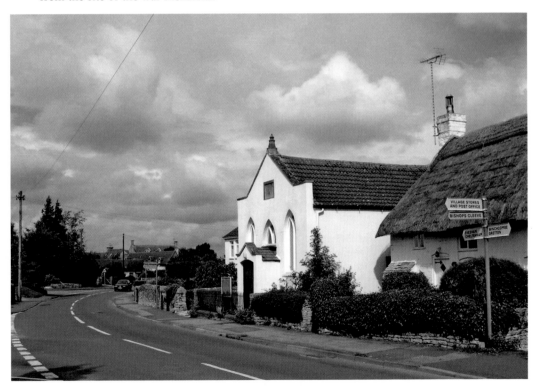

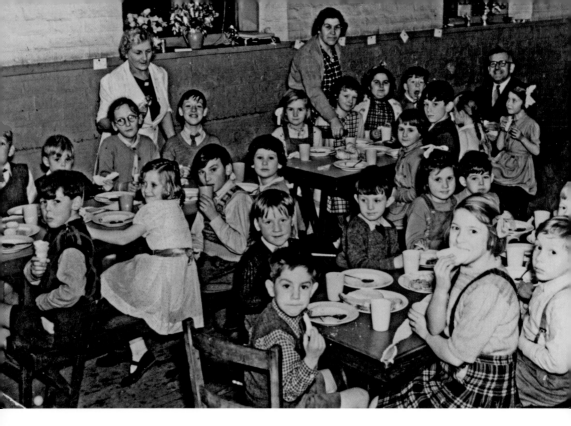

Gotherington School

The upper photograph of a school dinner under the watchful eye of Ted South, the chairman of the managers, was taken in the 1950s. A new school further along Gretton Road was opened in 1968 as the number of pupils increased. Then in 1984 the old school was converted into the houses seen in the modern photograph.

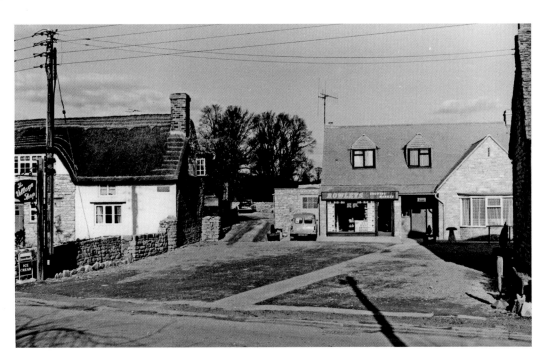

Rowley's Country Market

Another village shop that did not survive competition from modern supermarkets stood at 15 Gretton Road. Rowley's village shop was a second grocer's in the village in the 1960s and early 1970s before being closed and converted into a house. The other village shop still survives as Gotherington Post Office and Stores in Cleeve Road.

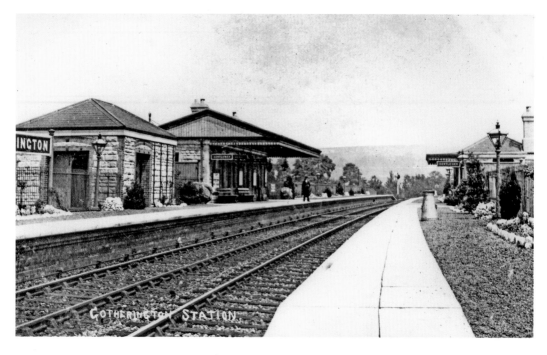

Gotherington Station

The station opened in 1906 to serve Gotherington, Prescott and Woolstone but was not really convenient to any of them. There were never many passengers or freight, as evidenced by the single milk churn in the upper view. Until closure in 1955 the train linked the village to Bishop's Cleeve. After closure the main building was converted into a character home. The reopened Gloucestershire and Warwickshire Railway line serves only the rebuilt platform from which the modern photograph was taken.

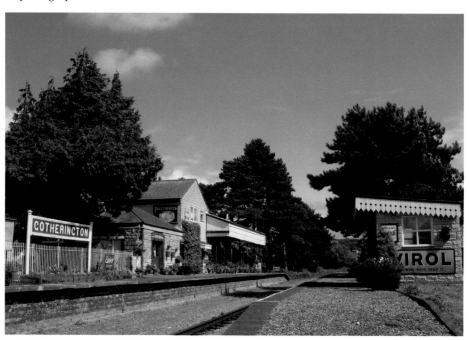

chapter 3

Woodmancote

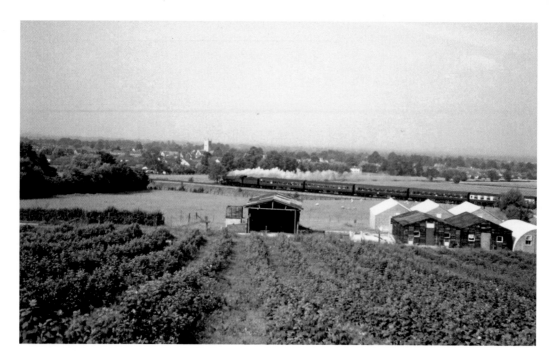

Minetts' Fruit Farm

The railway which linked Gotherington to Bishop's Cleeve formed a boundary between Bishop's Cleeve and Woodmancote. Minetts' fruit farm offers a vantage point in photographing a southbound passenger express in July 1965. Forty-five years later it is a train of the preserved Gloucestershire and Warwickshire railway, headed by 9F locomotive *Black Prince*, which is recorded running across the now bare fields against the background of an expanded Bishop's Cleeve.

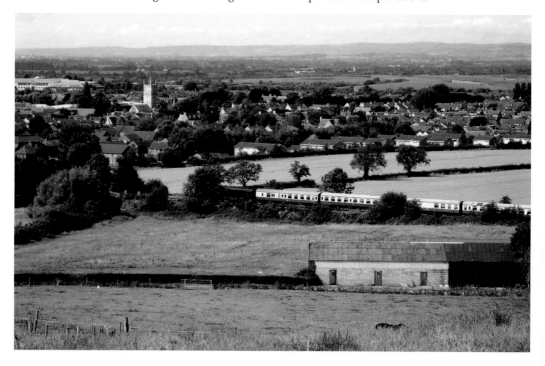

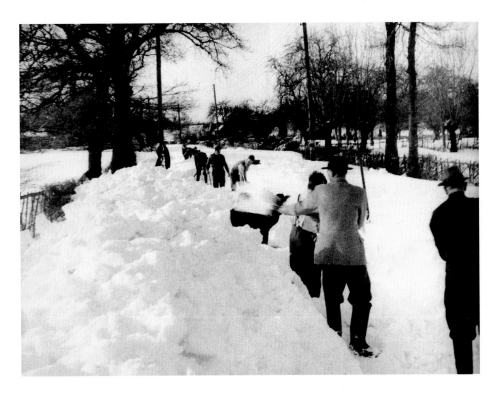

Station Road

The bitter prolonged winter of 1946-47 brought with it heavy falls of snow that completely isolated Woodmancote for a time. A team of villagers worked non-stop to free the community from its icy bondage. They are seen here working their way towards the railway station. Today the serenity of a summer's morning belies the scene of that desperate struggle over sixty years earlier.

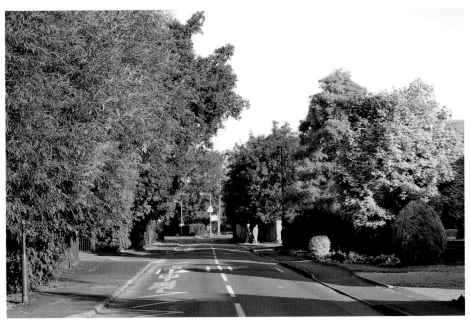

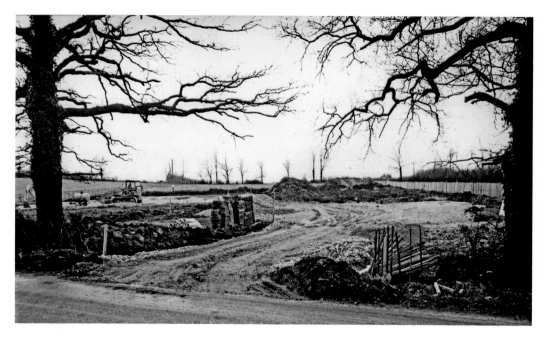

Woodmancote School

Woodmancote schoolchildren had to travel to neighbouring Bishop's Cleeve and beyond for their daily education until an ever-growing population justified the building of a village school. The bulldozers moved onto the site in Station Road in 1973. The school has since been greatly expanded under a continual building programme. The modern view shows the entrance from a slightly different angle to the earlier view.

The Longlands, Station Road
Longlands field stretched from Station Road up to Butts or Breeches Lane. Planning permission to develop was granted only after much deliberation and argument, and the early years of this century saw the building of this large Cotswold-style estate on pasture land where cows grazed only a few years before.

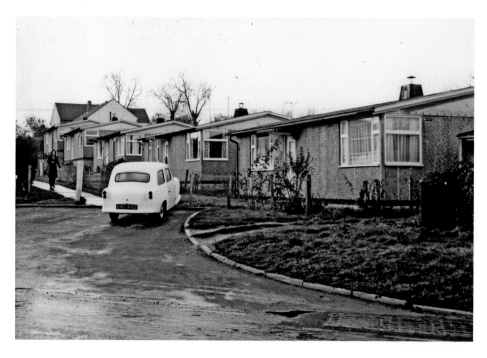

Crowfield 'Prefabs', Station Road

These prefabricated single-storey dwellings were designed to alleviate the chronic post-war housing shortage, and ten had been built on Crowfield by 1947. They served the community far beyond their intended lifespan and were finally replaced by the modern reconstituted Cotswold stone, warden-controlled bungalows on the same site in the late 1980s.

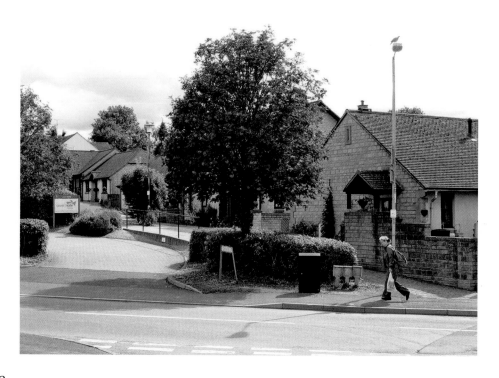

Roseville, Bushcombe Lane

Few people today turning into Aesop's Orchard would recognise the lower view! For fifty years Roseville was the home of Jim and Annie Surman, both from old local families with roots in Woodmancote. On their deaths in the 1960s the house and adjoining orchard were sold to developers and the result is seen here as the entrance to the development.

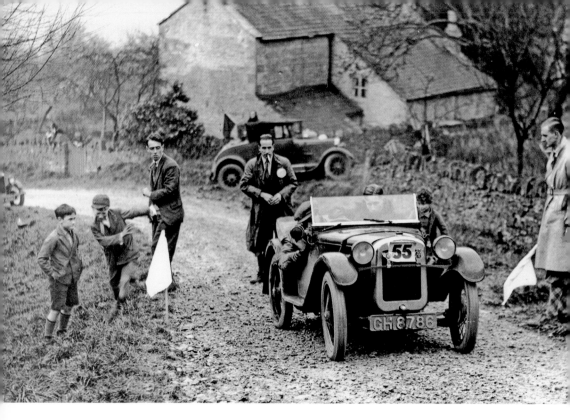

Bushcombe Lane

Long before the Second World War, the steep lanes of the Cotswold escarpment attracted motor sports events, including the famous Midlands Colmore trophy. Here a 1930 Austin Seven is attempting a stop-start test on the approach to the steepest section of Bushcombe Lane during a rally of 1932. Today the twenty-five per cent (one in four) gradient still poses a formidable challenge to some modern vehicles, despite the road now enjoying a solid tarmacked surface.

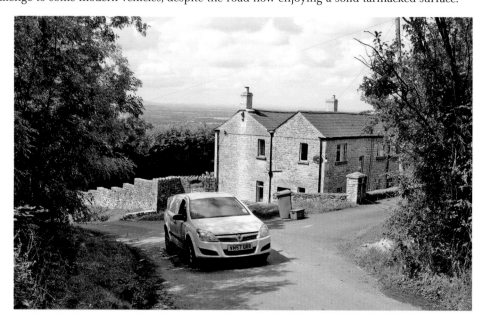

Northam Stores and Perrin Terrace

In 1950 a young man, Martin Coombes of Nutbridge Cottages, took a picture from his bedroom window across Station Road to Cleeve Hill beyond. The modern photograph was taken through the same window some sixty years later with Martin still residing in his old home. The overgrown wide roadside verge in the earlier view has become the front gardens of subsequent housing, whilst the roof of the bus shelter can just be glimpsed under its covering of vegetation.

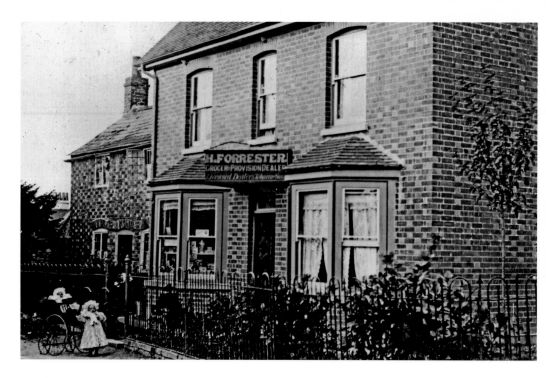

Northam Stores

The shop was established early in the twentieth century, trading from the front room of the house. Early proprietors were the Forresters whose two small daughters are posing here for the camera. The inset of 1955 portrays Frank Gould who later expanded the business with a purpose-built unit in order to cope with the increasing trade of the growing village. When the shop closed in the late 1970s it was converted into the private house seen here in the lower view.

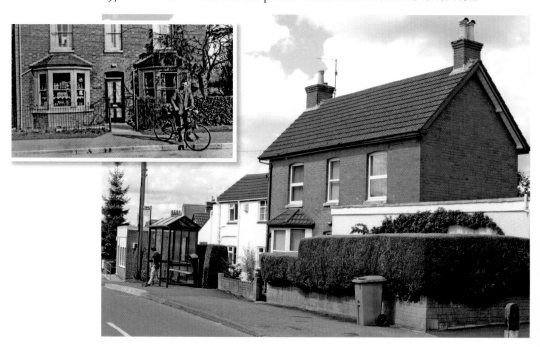

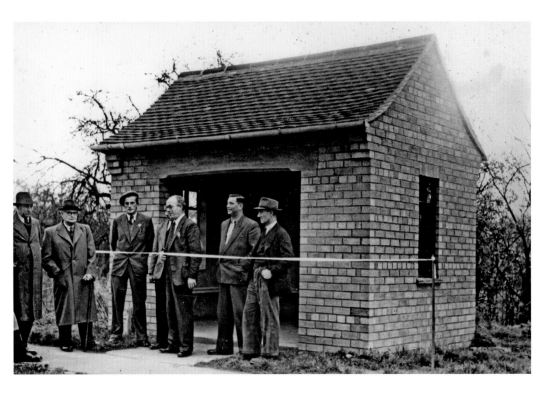

Woodmancote Bus Shelter

The original bus stop stood at the village green but it moved to the top of Station Road with the building of the bus shelter as Woodmancote parish council's contribution to the Festival of Britain in 1951. Its opening was considered sufficiently grand for this formal ceremony, attended by the chairman of the parish council, the builders and other local dignitaries. Notice that they are mostly standing on the wrong side of the tape!

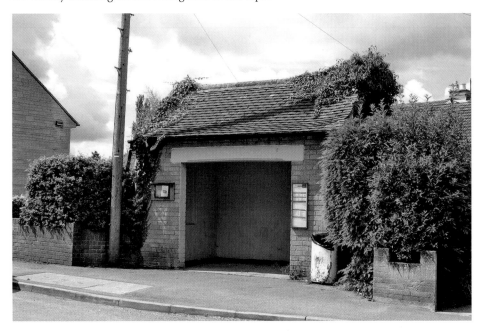

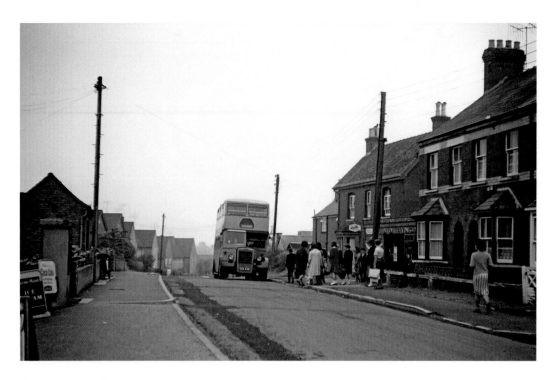

Woodmancote Bus Stop
The stone shelter is little used today as the buses run to Cheltenham from the opposite side of the road and passengers can wait in the new modern steel-framed glass awning. Forty-five years separate these two photographs, the Kearsey's ancient grey double-decker being replaced by the hourly circular service of modern metro-style buses. Note the number of passengers queueing for the 8.25 a.m. bus on 22 July 1964.

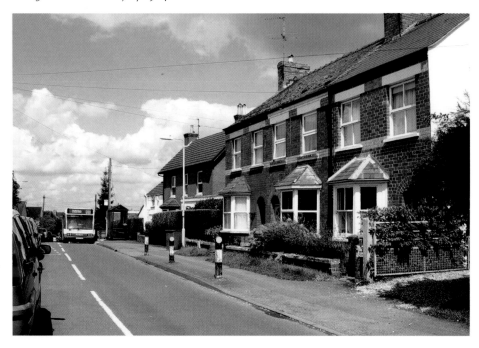

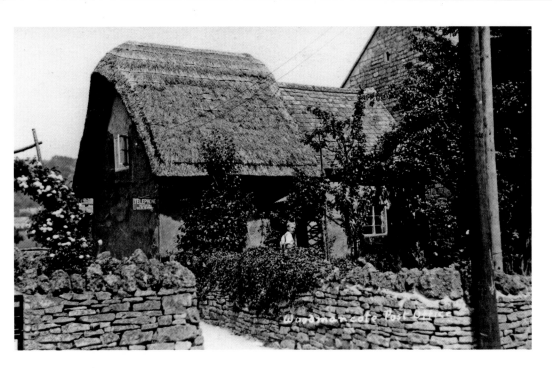

The Post Office at The Green

This quaint timber-framed thatched property houses the village post office run by Effie Surman as seen here in the 1920s. Sadly the building was condemned in about 1948 and its last occupants Dick and Nora Stewart moved into a new home at Crowfield, the then recently constructed prefabs a few hundred yards down the road. Now the plot has become part of a private garden screened by high bushes.

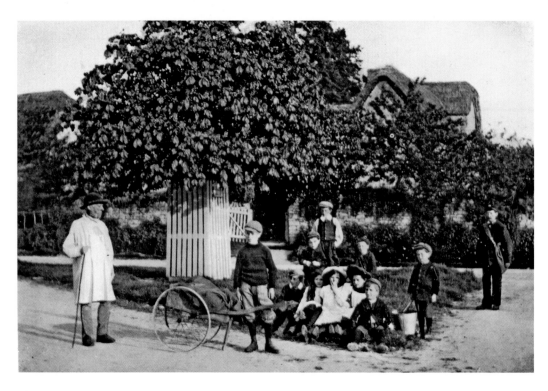

The Green

For generations The Green, set at the meeting place of the village's three main roads, was a traditional place for the children of the village to congregate. The charming period view, taken *c.* 1915, portrays a group of local 'hobbledehoys' with Harry Allen, the postman, and old Mr Potter of the neighbouring King's Farm.

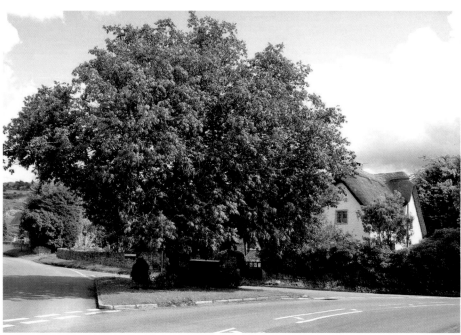

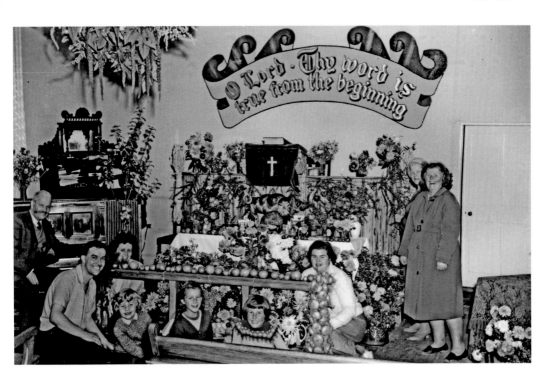

Countess of Huntingdon's Chapel, Stockwell Lane

Its tiny bell has been calling villagers to worship since the chapel's construction in 1854. The annual harvest festival is held every autumn and our picture here shows the local people gathered around a traditional display of produce in October 1965. The adjacent cottage was once the home of the late Mrs Little, remembered by older inhabitants today as the chapel's charismatic caretaker with her ready wit and colourful turn of phrase!

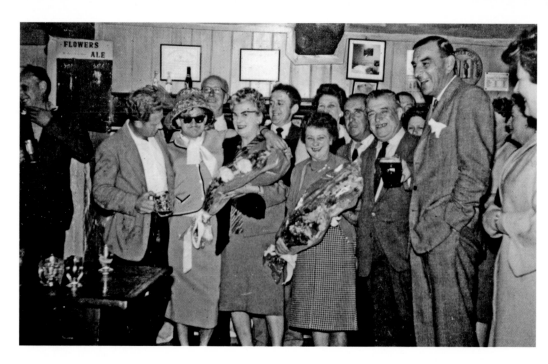

The Apple Tree Inn, Stockwell Lane

A presentation is being made to the landlady, Mrs Frances Gill, probably on her retirement *c.* 1961. Her long-serving bar lady, Mrs Vera Rowe, has also received a bouquet of flowers. Surrounding them are her regular customers, including National Hunt jockey, the late Johnie Lehane, inexplicably dressed in female clothes! Today the Apple Tree is much extended to cater for an ever-growing restaurant trade upon which many traditional country inns now depend.

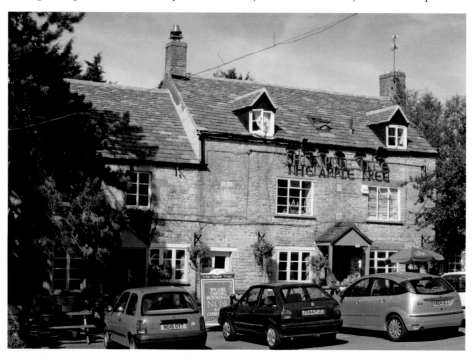

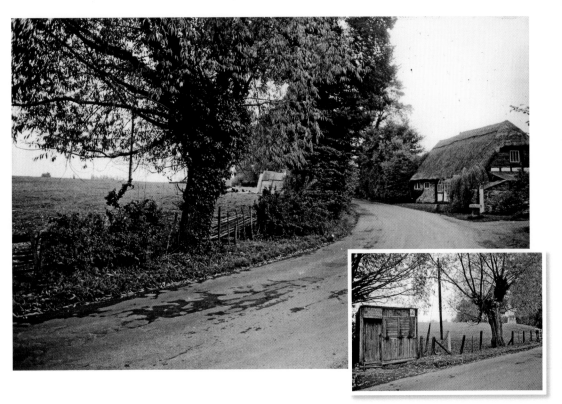

New Road

New Road from the village green followed the boundary of Pottersfield, marked by the line of elm trees and ancient willows. The quaint wooden lock-up shed in the corner of the field housed the village cobbler, 'Sam Powers, Practical Boot and Shoe Repairer'. In 1965 Pottersfield was developed as a housing estate, hidden in the modern picture behind a screen of tall bushes, whilst opposite, Poplar Farm remains looking much the same as forty-five years earlier.

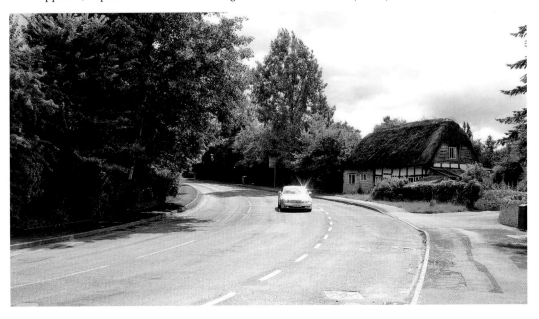

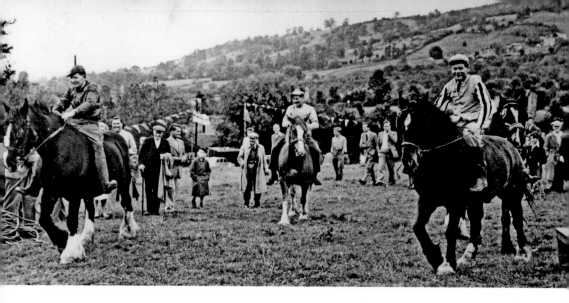

Pottersfield

Pottersfield was the village's unofficial recreation ground for many years, hosting annual flower shows, fêtes and even Woodmancote Cricket Club. Pictured is a Woodmancote carthorse derby of the 1950s, when farm horses were raced bareback by fearless local lads around a crude circular course, roughly roped off around the field's perimeter. Today the only grass is on the neatly trimmed lawns of the houses in Cranford Close. In the background Nottingham Hill provides a reference point for the earlier scene.

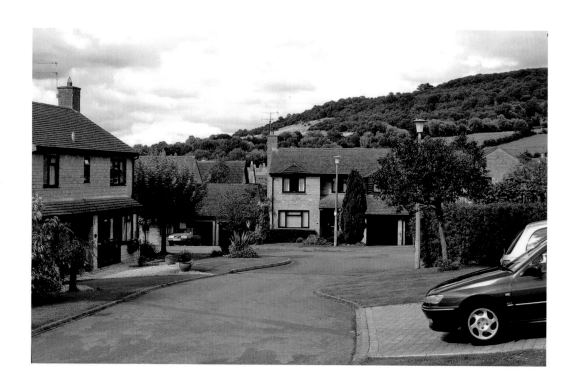

Gambles Lane Crossroads

Although separated by only about twenty-five years, these views of the crossroads where New Road is crossed by Two Hedges Road running into Gambles Lane, show several differences. The large conifer in the front of the thatched cottage has gone, the tall chimney on the nearest property removed, the finger signpost has shifted away from the corner; all subtle changes that together make the more modern aspect.

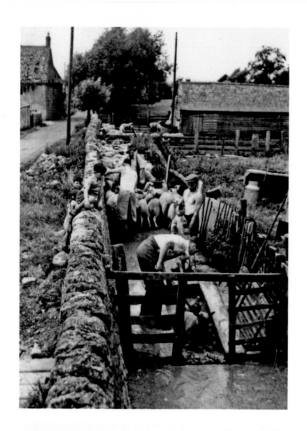

The Sheep Dip at Lower Bottomley Farm, Gambles Lane

Here in the farmyard fronting Gambles Lane, Farmer Denley and his men perform the ritual of the annual dipping of the flock. In the middle distance, across the lane, can be seen the gable end of Woodmancote Farm. Once again modern gardens dominate the scene.

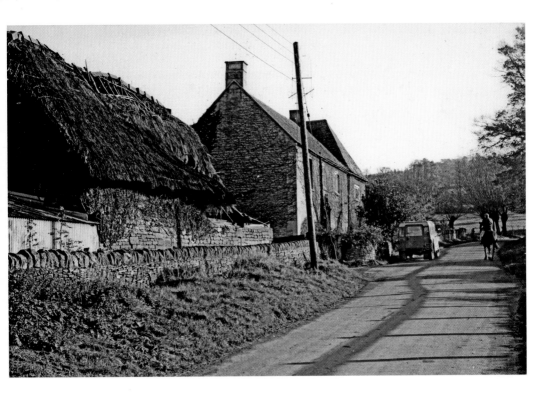

Lower Bottomley Farm House

The older picture, taken in 1970, portrays Lower Bottomley at the end of its life as a working farm. Many of its fields have been developed for housing and the barns and outbuildings lie derelict. Today the house is much restored and modern cars are garaged where once cider apples were crushed in the old thatched cider mill house.

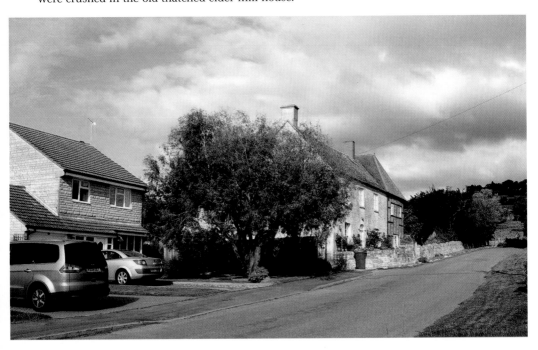

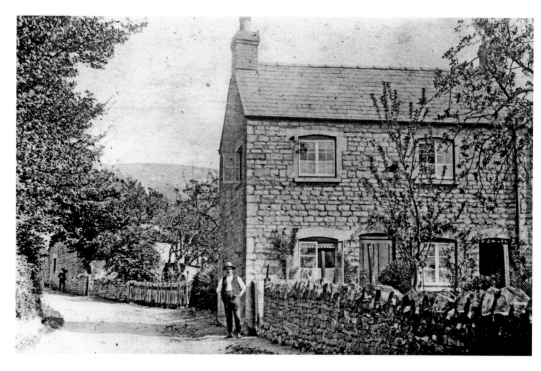

Hillside, Gambles Lane

Just before the lane begins its steep ascent towards Cleeve Hill, a small cluster of cottages line its right bank, all now greatly restored or even rebuilt. Hillside has had its southern wall concealed by a large new wing, which virtually doubled its original size seen in the upper photograph of *c.* 1915.

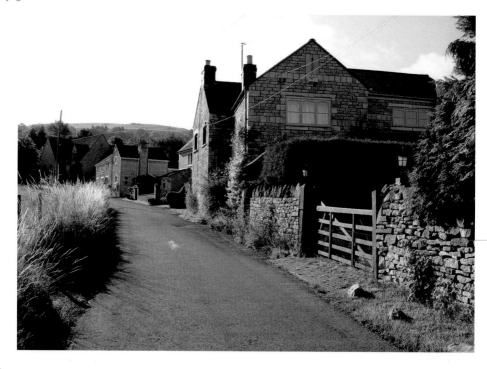

Brook Cottage, Chapel Lane

Once set amidst the orchards of Chapel Lane, Brook Cottage became surrounded by the new Greenway housing development in the mid-1950s. On the departure of owner Jim Hart and his wife it was demolished to make way for a row of detached houses fronting the little babbling brook, which now forms a water feature in their landscaped front gardens.

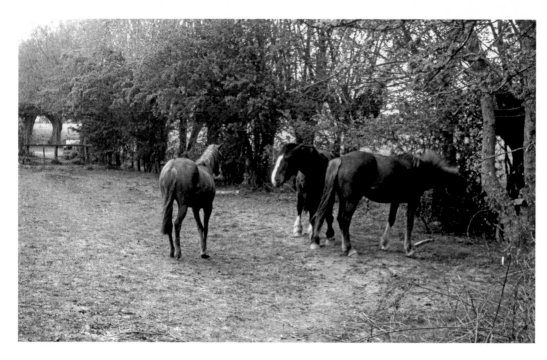

Woodmancote Vale

There was once a delightful footpath through the fields leading from Chapel Lane in Woodmancote, following the course of the brook into Bishop's Cleeve along Pecked Lane. Despite much local opposition arguing that the estate would join Woodmancote to Bishop's Cleeve, development took place during the late 1970s, but the line of the old footpath is preserved in a hard-surfaced path which follows the brook, now neatly contained in a concrete gully, but sadly horses no longer graze along its banks!

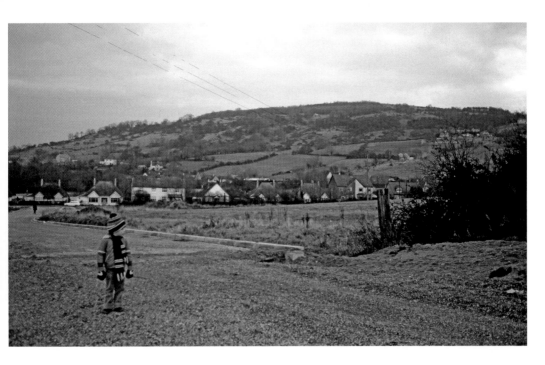

Woodmancote Vale
The line of Britannia Way was laid out before any building took place. In the winter of 1980-81 a toddler stands where the road crosses a field boundary between Woodmancote and Bishop's Cleeve. Nearly thirty years later, the toddler has returned but is no longer able safely to stand in the road itself. As in other pictures, the background of Nottingham Hill gives a reference point for the two photographs.

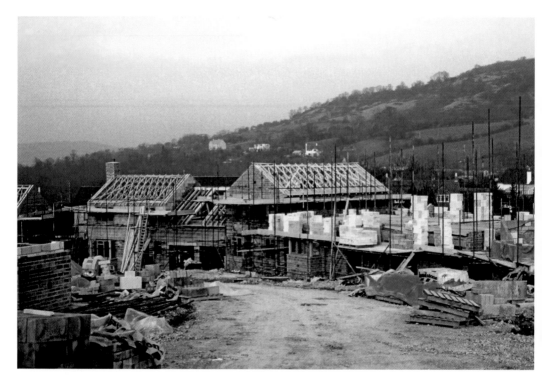

Celandine Bank, Britannia Way

The northern end of the estate is built on the rising ground of the old Crowfield and affords a pleasing view across the rooftops towards the slopes of Nottingham Hill. The upper photograph, showing the houses under construction, is another photograph from the collection of Peter Lewis. It was taken in 1983.

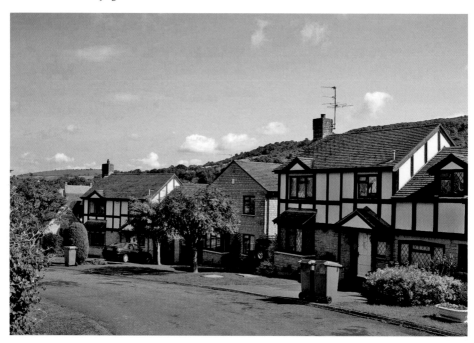

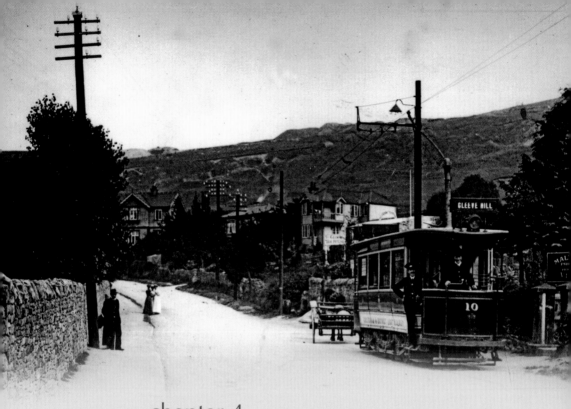

chapter 4

Cleeve Hill
and Southam

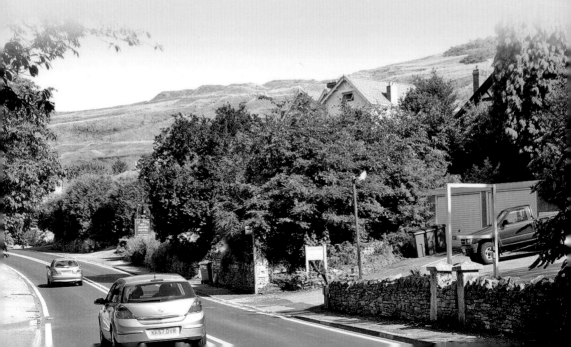

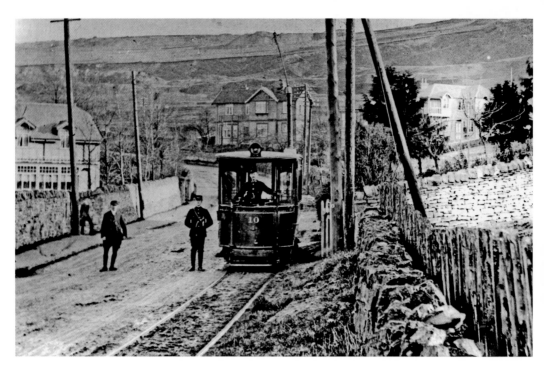

The Tram Terminus at the Malvern View

The tramway was laid to Cleeve Hill in 1901 but lasted barely thirty years. A tram here awaits the return trip back down the hill to Southam. Only single-decker cars ran up the steep gradient for safety reasons, passengers changing from double-deckers at the foot of the ascent in Southam Village. Today's visitors to the hill usually travel by car or use the bus service that runs between Winchcombe and Cheltenham.

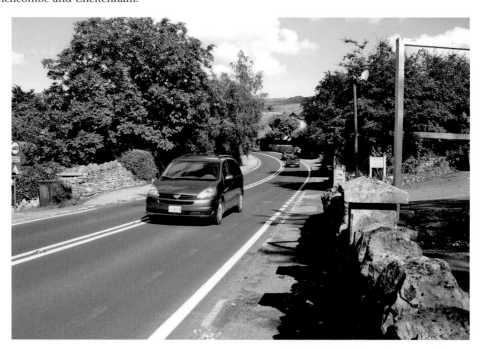

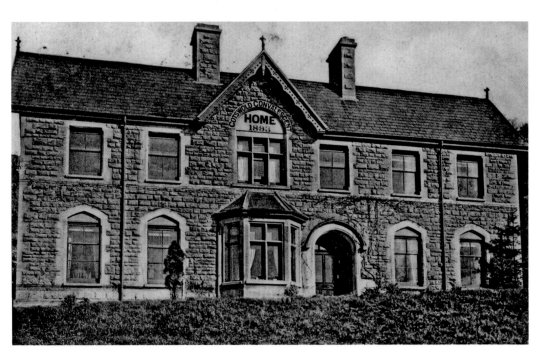

The Cotswold Convalescent Home

When the home opened in 1893, overnight Cleeve Hill became the Cotswold Health Resort. Taken over by the Red Cross during the First World War, in 1923 the home came under the ownership of Courtaulds before becoming a private nursing home in 1979. The modern photograph shows how much it has expanded from its original size. It enjoys panoramic views across the Severn Vale with the Malvern Hills in the distance.

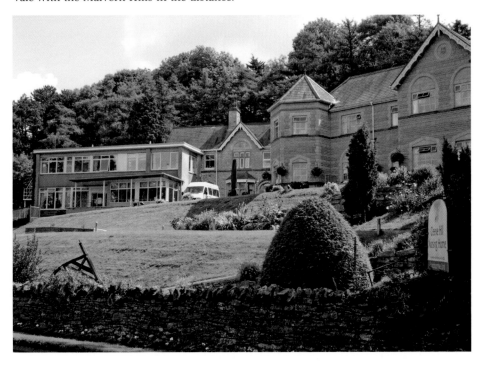

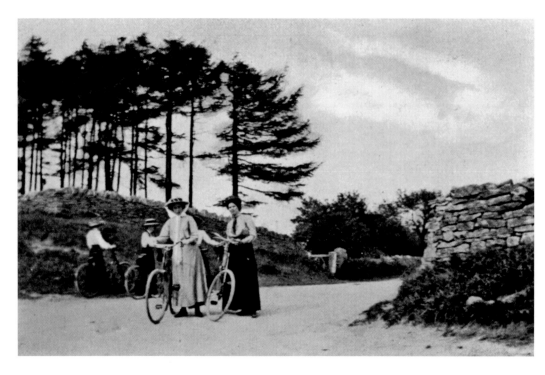

Wickfield Lane

As Granna, or Grinnell, Lane this has risen from Gotherington to cross the main Cheltenham to Winchcombe road at its highest point to continue onto Cleeve Common. The upper view, from Dr Garrett's book *From A Cotswold Height,* shows four Edwardian lady cyclists who have made a Herculean effort by pedalling their heavy machines to this high point, dressed head to toe in such formal attire! The car indicates that today's visitor does not need to make any such effort.

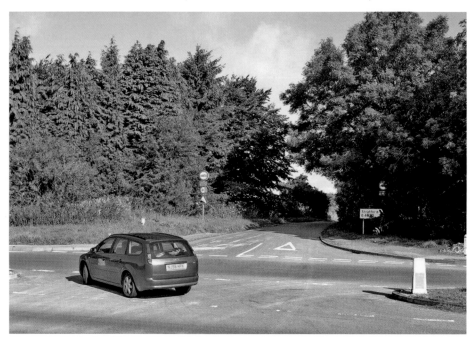

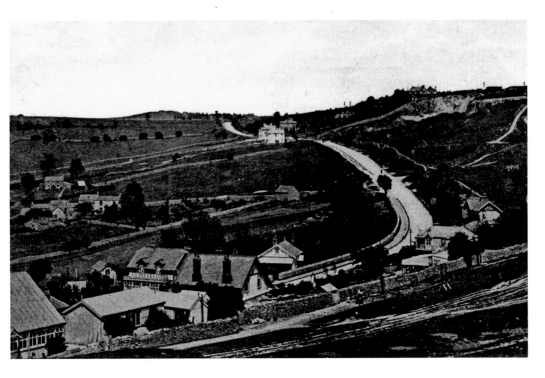

Cleeve Hill Looking North

The main road to Winchcombe dominates the old picture, but the subsequent growth of vegetation has changed the scene considerably. The road is barely visible nor are many of the earlier houses. The bare gash of Milestone Quarry in the distance has been mellowed by the passing years, as have the tracks across the common, worn by horse-drawn carts during the heyday of the stone quarrying industry, which had all but disappeared even a century ago.

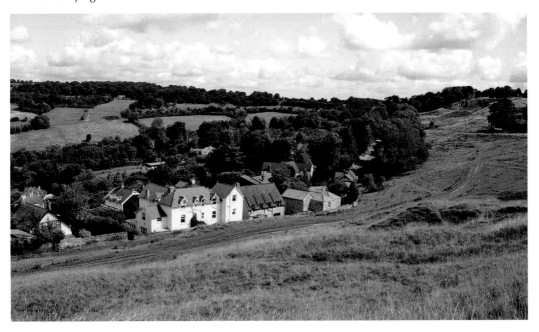

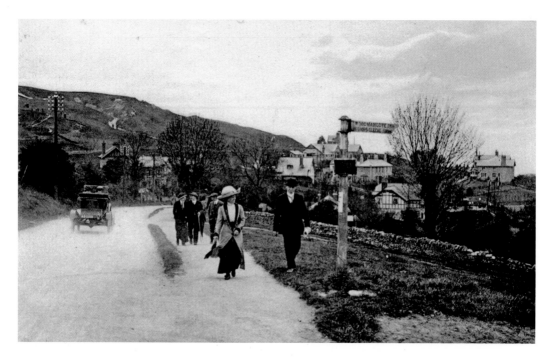

At the Top of Stockwell Lane

This group of smartly dressed Edwardians are 'taking the air'. The signpost is pointing down Stockwell Lane to Woodmancote and Bishop's Cleeve. The registration number of the passing car can be dated to Worcestershire in 1904, which gives an approximate date for the postcard. This was the period when Cleeve Hill was regarded as a fashionable resort, frequented, particularly on sunny weekends, by the fine, and not so fine, inhabitants of Cheltenham — 'trammists' according to one local newspaper!

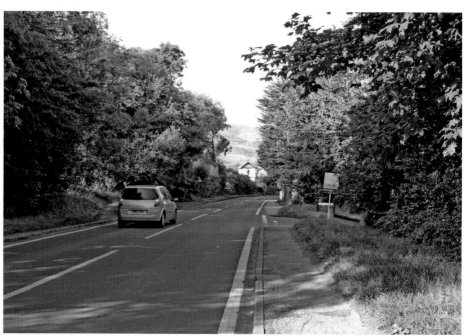

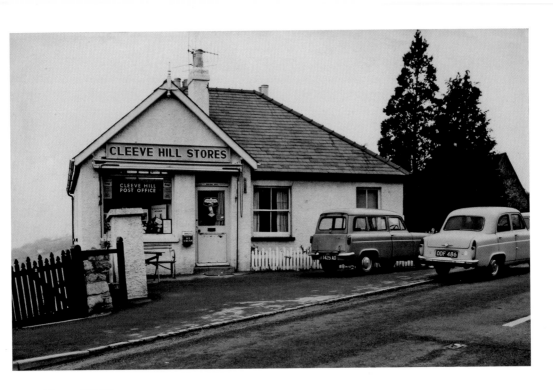

Cleeve Hill Stores

The stores and post office served the little community of Cleeve Hill and was a welcome sight for walkers who had the chance to buy a thirst-quenching drink or an ice cream. In common with many small shops it closed for business and in 1979 was converted into a private dwelling by the Lunt family who continue to live there.

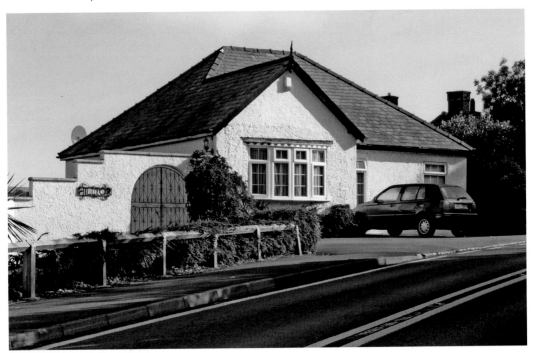

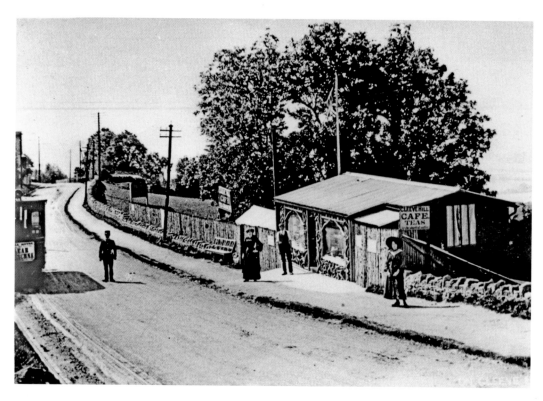

Cleeve Hill Café

In 1911 this rustic wooden café boasted 'parties of 200 catered for at a moment's notice'! It also provided simple rides and swings in its extensive terraced garden, which can still be seen behind the rails in the modern picture. The conductor of a tram pauses proudly for the camera. Beyond the tram can be glimpsed the Rising Sun Hotel. St Peter's church opened next to the café in 1907, closing for worship exactly 100 years later.

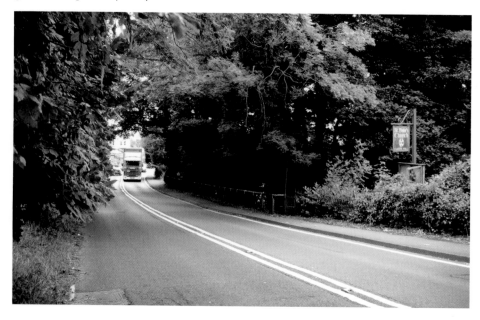

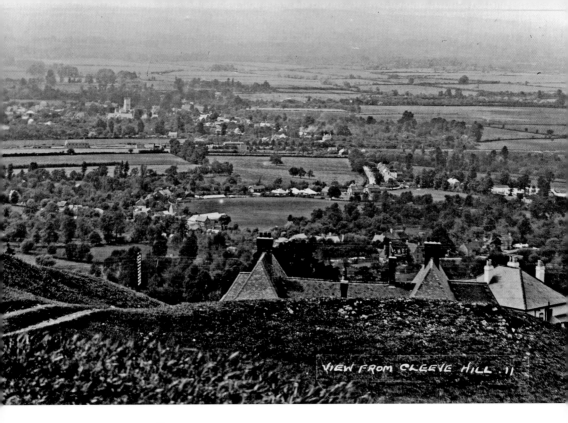

'View from Cleeve Hill'

A comparison between these two photographs taken just over a century apart shows the staggering growth of Bishop's Cleeve and Woodmancote during the period covered by this book. Yet despite all the changes, the tower of St Michael's church is clearly visible in both views. In the immediate foreground, just showing above the rising ground, is the roof of the Cheltenham Town Golf Clubhouse, which dates back to 1905.

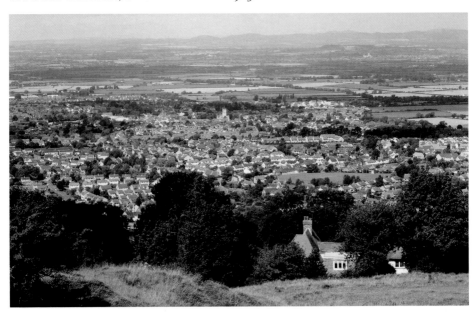

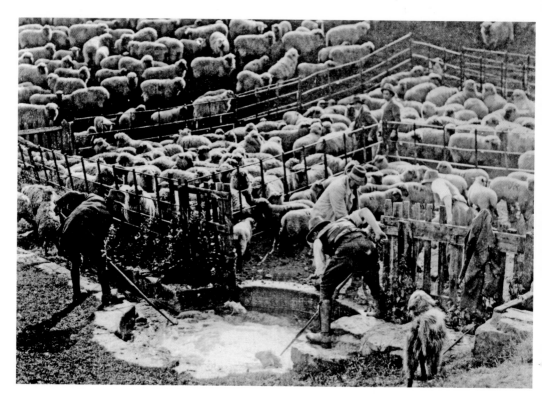

The Washpool

The Washpool was built in 1897. It was formed by the damming of the infant River Isbourne as it flows down Watery Bottom. This supplied the stone-built dipping bath with a ready source of clean water. Large numbers of commoners' sheep roamed the common, as evidenced by the interwar scene of a team of men busy dipping their flock, watched by a rather bemused sheepdog. Today the long-disused dip has been restored and then fenced off for safety reasons.

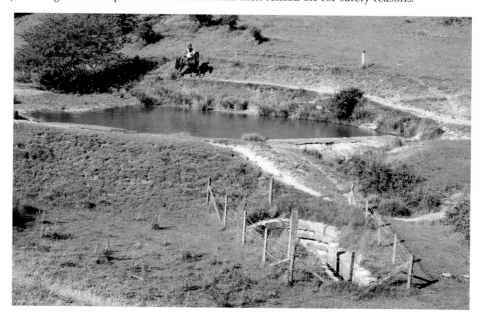